PAST & PRESENT

AROUND LAKE WASHINGTON

Well-known photographer Asahel Curtis took this 1910 photograph of a winding hillside road for a promotional brochure about Lake Forest Park, a residential suburb just north of Seattle. The image shows what is now Northeast 178th Street east of Ballinger Way, a backroad still twisty enough to be dubbed "the goat trail" by locals. The brochure touted "the magnificent sweeps of forest green and the vista of beautiful Lake Washington." (Courtesy Shoreline Historical Museum, LFP SHM 1910 A.)

PAST & PRESENT

AROUND LAKE WASHINGTON

Eleanor Boba

Library of Congress Control Number: 2020943302

Published by Arcadia Publishing
Charleston, South Carolina

Printed in the United States of America

For all general information, please contact Arcadia Publishing:
Telephone 843-853-2070
Fax 843-853-0044
E-mail sales@arcadiapublishing.com
For customer service and orders:
Toll-Free 1-888-313-2665

Visit us on the Internet at www.arcadiapublishing.com

ON THE FRONT COVER: Ida Conrad enjoys an afternoon by the lake in Kenmore with her children Betty and Gordon in 1923. During logging days, many spots around the lake became clogged with chained groups of logs called "booms." In the 1960s, this spot at the extreme north end of the lake was officially named Log Boom Park. It remains a popular place for swimming, fishing, and boating. (Past image courtesy Shoreline Historical Museum, SHM-723-A; present image by the author.)

ON THE BACK COVER: Leschi was a popular pleasure garden at the turn of the 19th century. The lakeside community took off thanks to cable cars from downtown Seattle and ferry service on the lake. In this 1906 image, folks wait for entertainment to begin. (Courtesy PEMCO Webster & Stevens Collection, Museum of History and Industry, 1983.10.7529.)

Contents

ACKNOWLEDGMENTS

This book would not have been possible without the cooperation of the following photograph repositories and individuals who provided the historic (and a few modern) images. To save limited space, acronyms have been used in many cases to credit institutions that provided multiple images:

Archives of the Archdiocese of Seattle
Black Heritage Society (BHS)
Densho
Eastside Heritage Society (EHS)
Kenmore Heritage Society
Kubota Garden Foundation
Museum of History and Industry (MOHAI)
National Archives and Records Administration (NARA)
John L. O'Brien family
Karen L. O'Brien
Pacific Northwest Railroad Archive
Puget Sound Maritime Historical Society (PSMHS)
Renton Historical Museum (RHM)
Rainier Valley Historical Society (RVHS)
Seattle Municipal Archives (SMA)
Seattle Public Library (SPL)
Shoreline Historical Museum (SHM)
Yousef Shulman
Kyle Stetler
Mikala Woodward
US Army Corps of Engineers/Friends of the Ballard Locks (USACE)
University of Washington Digital Collections (UW)
Washington State Historical Society (WSHS)

All contemporary photographs not otherwise credited were taken by the author.

For a complete list of photograph and quotation attributions, please see the website: remnantsofourpast.blogspot.com/2020/06/historical-images-of-lake-washington.html.

Sincere thanks to Nancy Dulaney, Rainier Valley Historical Society; Valarie Bunn, Seattle historian; Vicki Stiles, Shoreline Historical Museum; and Elizabeth Stewart, Renton History Museum, for reviewing the text. Finally, special thanks to Alan and Alida Humphrey, who accompanied me on many quests to find present spots, and to Gary Boba for inspiring the project although he doesn't know it.

INTRODUCTION

This book explores how Lake Washington has shaped the lives of its people, and how people have shaped the lake.

The lake is and has been a hub of human activity, from the native peoples who first lived and fished here to the settlers who arrived in the mid-19th century and their descendants to recent immigrants, refugees, and transplants.

Lake Washington both defines and reflects the development and history of Seattle, Bellevue, Renton, and surrounding communities. This inland freshwater lake provides the eastern boundary of the City of Seattle, while saltwater Puget Sound marks its western extent. The lake is long (about 20 miles) and narrow (one to four miles across); the water depth averages 108 feet but sinks to as much as 214 feet at its deepest point. In several locations, ghostly stands of forest trees remain at the lake bottom, placed there by ancient landslides. The lake was formed during the retreat of the Vashon glacier many millenia ago. Other natural events, such as volcanic eruptions, had a part in shaping the lake's contours and geology long before the hand of man set out to make improvements.

The water known as Xacuabš to the native Americans, Lake Geneva or Lake Duwamish to the first white explorers, and finally Lake Washington, in honor of George, has provided livelihood, transportation, and recreation to many generations. Balancing urban and industrial growth with a healthy ecology and fair access for all is a continuing struggle.

The history of the lake is shaped by several major factors that will be mentioned many times in the pages that follow. They include the 1916 lowering of the lake and related engineering projects, the parks design of the Olmsted brothers for the west shore of the lake, and the effect of extractive industries (timber, coal, fishing) on the ecology of the lake and surrounding lands and waterways. Heavy industry, especially at the south end of the lake, and a military base at Sand Point in Northeast Seattle have left indelible marks on the landscape.

A century ago, civic boosters dug a canal from sound to lake allowing oceangoing sailing ships, lumber and coal barges, naval vessels, and pleasure craft to transit from saltwater to fresh via the Ballard Locks in Seattle. One result of this engineering feat was that Lake Washington dropped an average of nine feet, changing the contours of the lake and choking off the previous outlet, the Black River, with major consequences for ecology and native settlements.

In the early decades of the 20th century, the Olmsted brothers designed long stretches of parkland on the western shore, forming part of Seattle's "Emerald Necklace." Parks, beaches, and pleasure grounds were established on both west and east sides of the lake, served by ferryboats and streetcars before the automobile age. Floating bridges were built in 1940 and 1963, replacing the ferries.

By the 1950s, the lake was notorious for its high level of pollutants, the result of decades of industrial and domestic waste, making it unsafe for swimmers at its many beach parks. A major cleanup and the establishment of modern sewage treatment systems alleviated the problem, but booming industry and retail development continue to present environmental challenges and difficulties with public access. Nonetheless, many spots around the lake retain their natural beauty and opportunities for recreation and celebration, including the annual Seafair hydroplane races.

A NOTE ABOUT METHODOLOGY

How does one photograph something that is no longer there?

I set out to present a selection of past and present images of communities and natural areas. I soon found that, due to the massive changes over time to topography, ongoing development, and issues related to safe access, exact matches were not possible in many cases. Layered on top of this, a public health crisis that unfolded in the spring of 2020 added new obstacles in the form of closed parks, trails, and archives. Where matches are out of the question, I have endeavored to provide present-day images that reflect the changed landscape.

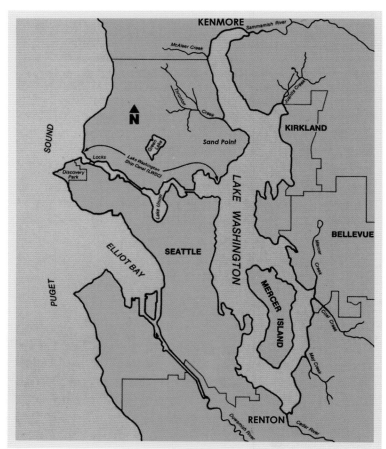

This map shows Lake Washington and its environs. (Courtesy US Government Printing Office.)

THE NORTH END

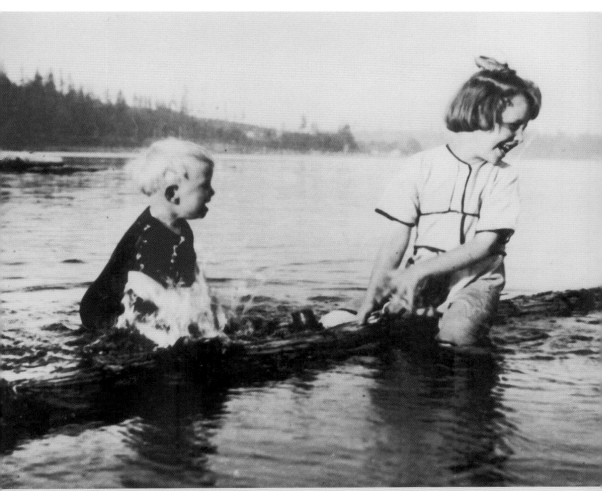

Six-year-old Barbara Drake and two-year-old brother Rush play with a driftwood log at the Lake Forest Park beach in 1919. The water appears to be about six inches deep at this popular spot on the lake's northwest shore. (Courtesy SHM.)

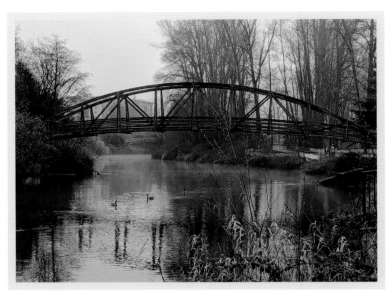

The Sammamish River was and continues to be the main inflow of water to Lake Washington at its northern end. Here, Frank Peterson paddles his canoe through the slough in 1915, one year before the cutting of the ship canal. The Sammamish has since been reengineered to aid navigation and reduce flooding. The mouth of the river is slightly west of its original position. Bridges have come and gone. The modern span at Bothell Landing Park, pictured here, is slated for replacement in 2020. (Courtesy SHM.)

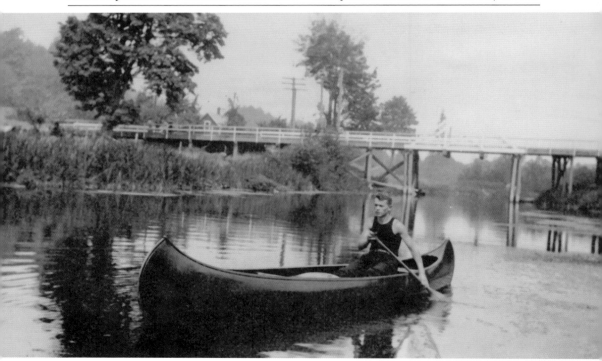

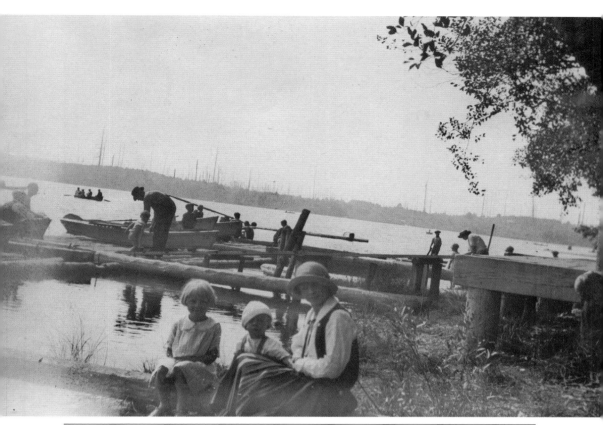

The Conrad family enjoys an afternoon by the lake in Kenmore in 1923. During logging days, many spots around the lake became clogged with chained groups of logs, called booms, as well as floating stray logs. In the 1960s, this spot at the extreme north end of the lake was officially named Log Boom Park. It remains a popular place for fishing and boating. A seaplane base, Kenmore Air Harbor, is next door. (Courtesy SHM.)

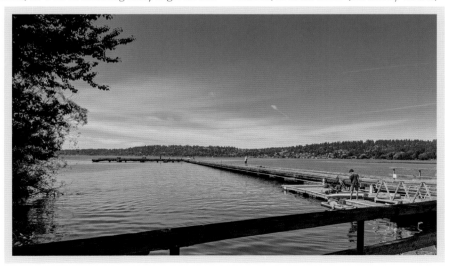

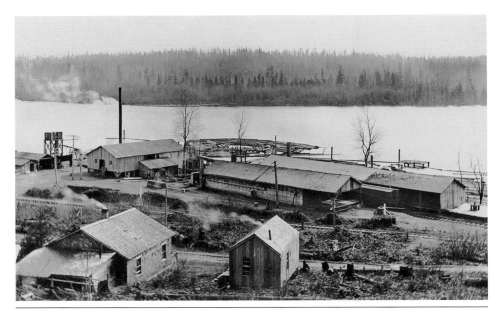

The McMaster Shingle Mill dominated the north shore of the lake in the Kenmore area for many years. Pictured here in 1909, the mill complex included a cook house, a store and post office, and a rail station along tracks that would later become the Burke Gilman Trail. Today's image shows that the dirt road has become a major highway. The area is still primarily industrial, with a concrete plant dominating the landscape. (Courtesy Kenmore Heritage Society.)

The Lake Forest Park Civic Club was established in 1924 on the lake shore and continues to serve as a place for social gatherings. Population in the suburb boomed throughout the century; in 1961, the community incorporated. Streams that brought salmon smolts down to the lake and adult salmon up to spawn now must run through culverts under streets and a highway. (Courtesy SHM.)

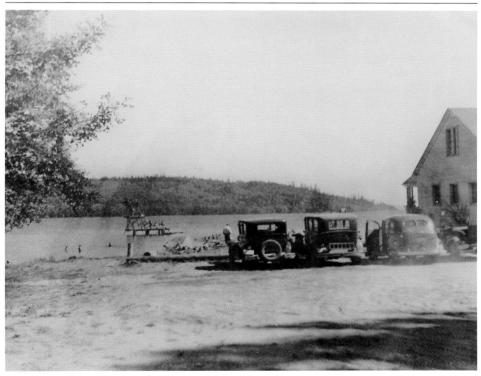

Children play at the lakeshore at Sand Point in 1920. Beginning about a century ago, the Northeast Seattle peninsula was physically altered to accommodate a naval support base: a small lake was drained, a bay filled in, small farms obliterated, and large swaths of trees and native vegetation leveled and paved for airstrips. The base provided logistical support for naval operations in World War II, the Korean War, and the Cold War. Today, the beach area is once again available for swimming and picnicking. (Courtesy SMA.)

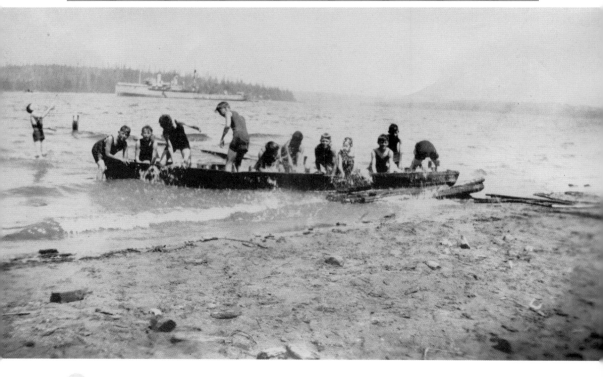

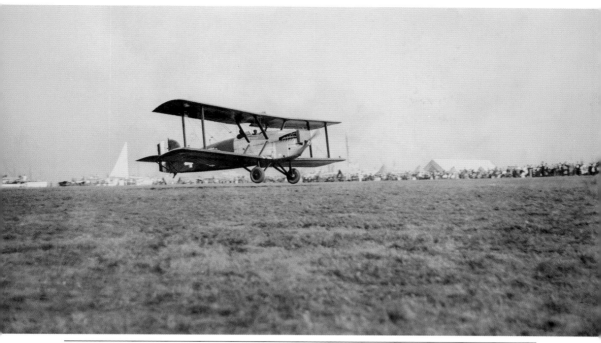

Four Douglas World Cruiser biplanes, fitted with pontoons, lifted off from a rough airfield on Lake Washington at Sand Point on April 6, 1924. Two of the original four completed the first aerial circumnavigation of the globe, landing back at the peninsula on September 28, an international sensation. A monument to the US Army Air Service flyers was dedicated that same year. It stands at the main entrance to the former naval base. (Courtesy MOHAI.)

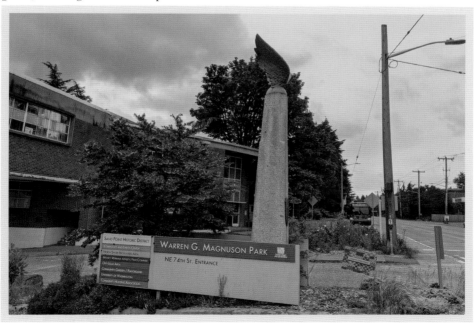

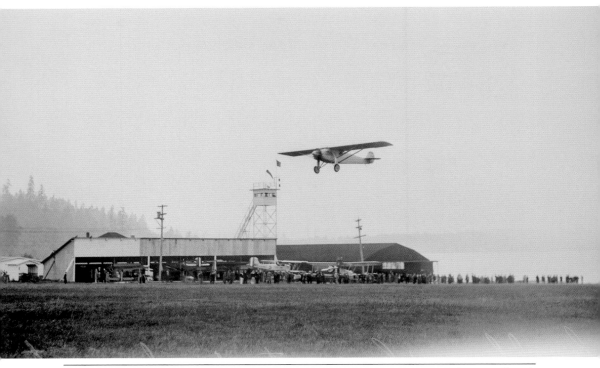

Four months following his record-shattering flight from New York to Paris, aviator Charles Lindbergh touched down on Pontiac Bay on the Sand Point peninsula. "Lucky Lindy" was on a publicity tour building interest in aviation. A crowd of 3,000 greeted him at the airfield on September 13, 1927. The *Seattle Star* reported, "And then Lindbergh appeared, swooping down out of the heavens from behind the hangars, as if by magic." Today, this section of Magnuson Park is home to several community organizations. (Courtesy MOHAI.)

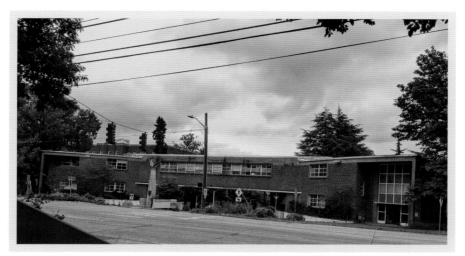

The historic photograph is dated 1940, before all base construction was completed. The contemporary photograph shows a large gatehouse structure. Naval Air Station Seattle was largely deactivated in 1970. Since then, dozens of community groups have competed for their share of the property now known as Magnuson Park. Some who grew up nearby remember the sounds of "Reveille," "Taps," and the weekly air raid warning test. (Courtesy MOHAI.)

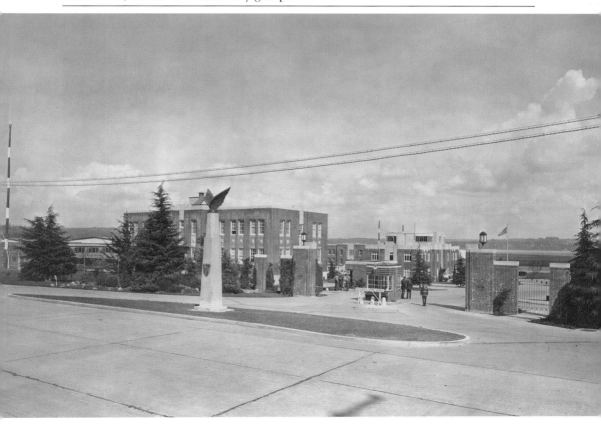

Early settlers in the Sand Point area established small farms and enterprises, including brick-making and shipbuilding on Pontiac Bay. A bit farther south, several Japanese families formed a collective farming community. In this c. 1925 photograph, the Uyeji family stands on their front porch just off the newly laid-out Sand Point Way. In 1944, the family's land and greenhouse were taken by the federal government to build a huge naval warehouse now operated by the National Archives and Records Administration. (Courtesy Densho.)

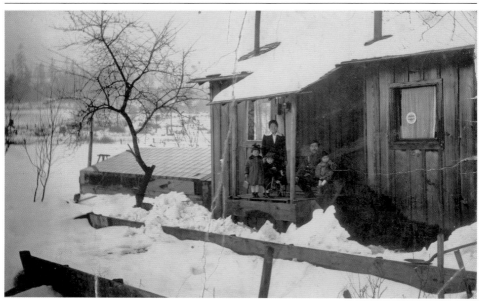

The National Oceanographic and Atmospheric Administration (NOAA) set up western regional headquarters at Sand Point in the late 1970s on part of the old naval base. The modern campus includes walking paths and artwork, including the innovative sculpture *A Sound Garden* with wind-created sound effects. And yes, the sculpture is the inspiration for the name of the grunge band. Since September 11, 2001, entry to the NOAA campus is closely monitored. In 2020, due to the Covid-19 crisis, no outsiders are allowed through the gates. Today's photograph was taken overlooking a walking path in Magnuson Park. (Courtesy SPL.)

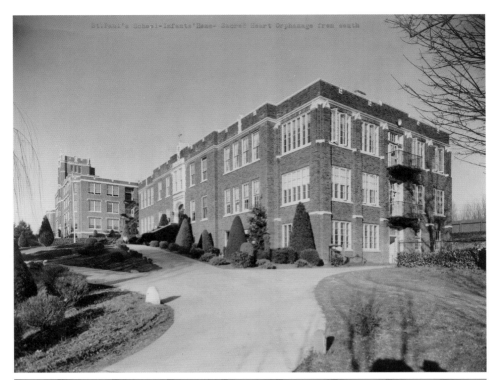

St.Paul's School-Infants'Home- Sacred Heart Orphanage from south

Missionary Sisters of the Sacred Heart, led by Mother Frances Cabrini, built an orphanage and school on a hill overlooking Lake Washington in 1922. Today the remodeled structure, once named Sacred Heart Villa Academy, is an independent Catholic school for prekindergarten through eighth grade known simply as Villa. The Italian-born Cabrini became a US citizen in 1909; in 1946, she was canonized—the first American saint. (Courtesy Archives of the Archdiocese of Seattle.)

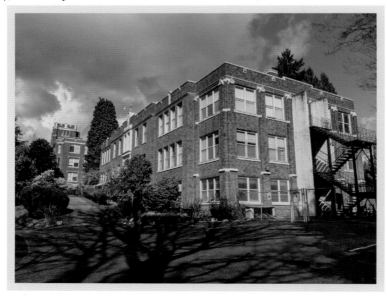

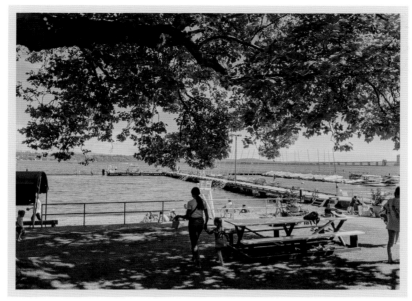

Families enjoy a summer day in 1955 at the Laurelhurst Beach Club. Founded in 1928 as a private retreat for members of the Laurelhurst neighborhood, the club is on the shore of Lake Washington on the peninsula known as Wolf's Point. In today's photograph, one can see the Evergreen Point floating bridge in the near distance, a span that did not exist in 1955. (Courtesy MOHAI.)

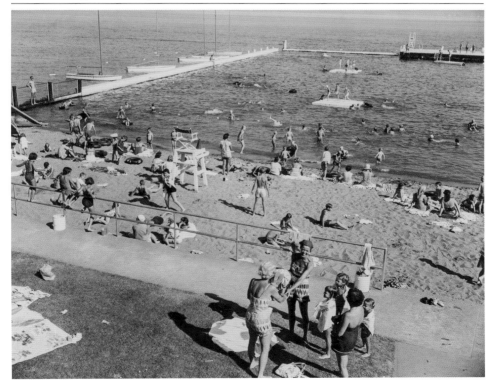

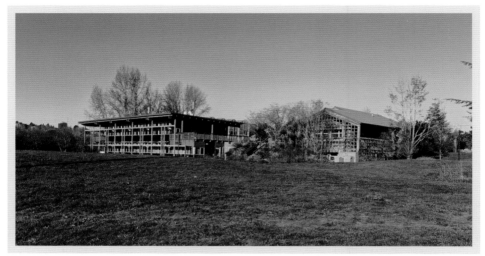

Henry Yesler's well-known mill was on Seattle's waterfront; his less-remembered mill was established in 1888 on Lake Washington's Union Bay, property that is now the University of Washington's Urban Horticulture Center. In this 1893 photograph, four adults and a child pose on top of massive logs floated in from the lake and loaded onto train cars. The tracks ran straight out into the lake on pilings. Remnants of the old wharf can be seen from the natural area called Yesler Swamp. (Courtesy SPL.)

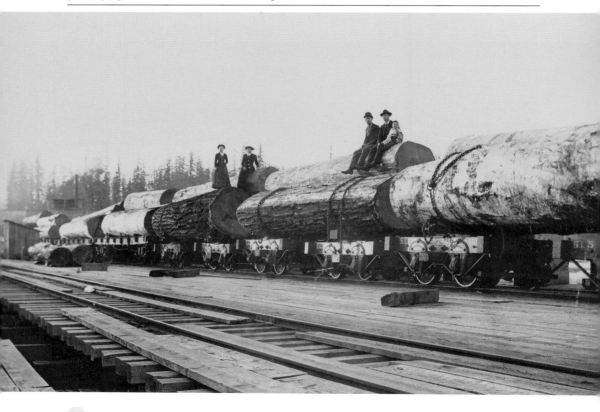

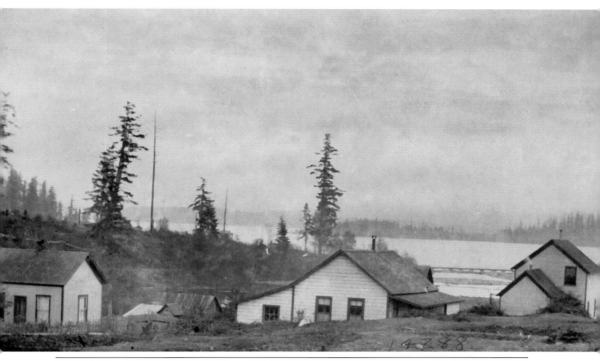

"Yesler Mill, a settlement of some sixty houses, with ice factory, church and stores, is doing a flourishing business and affords us lumber at $1 per thousand [board feet] cheaper than other mills." Thus did the *Seattle Post-Intelligencer* tout the small community that supported the mill in 1890. The 12 blocks that made up the town included two churches, a post office, and a candy shop. Today, few of the original small houses remain. (Courtesy SPL.)

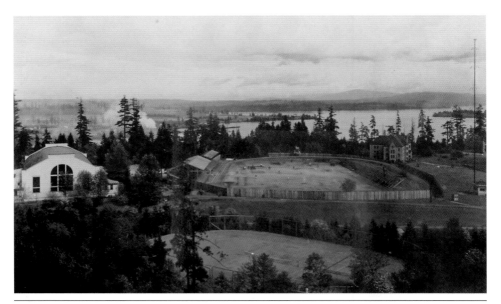

This 1908 photograph of sports fields at the University of Washington includes panoramic views of Union Bay, Lake Washington, and the Laurelhurst peninsula. From left to right are the gymnasium, Denny Field, and Lewis Hall, the men's dormitory. The school moved here from its original downtown location in 1895. Today, high-rise construction obscures the view from this spot, an archery field. (Courtesy UW.)

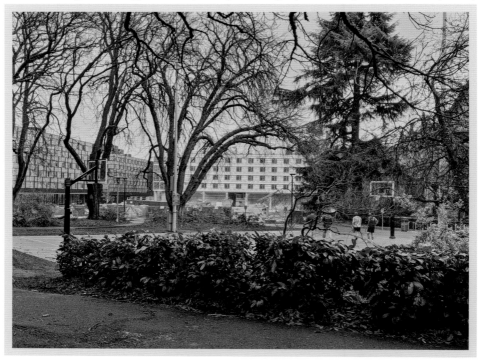

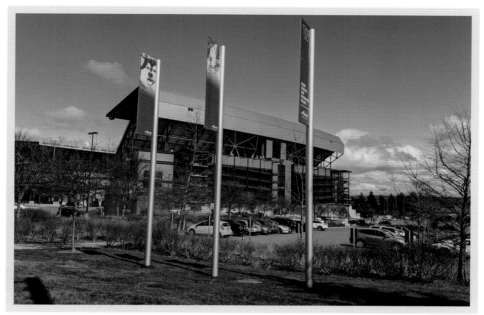

The University of Washington's Husky Stadium was constructed in 1920; at that point, football games moved from the old Denny Field. In the 1955 photograph, the stadium has only one grandstand. A second grandstand, seen at left in the present photograph, collapsed spectacularly during construction in 1987 before being completed in time for football season. In 1981, crowds at homecoming performed the wave for the first time in history. The stadium boasts a clear view of the lake; fans can listen to the game from their boats. (Courtesy MOHAI.)

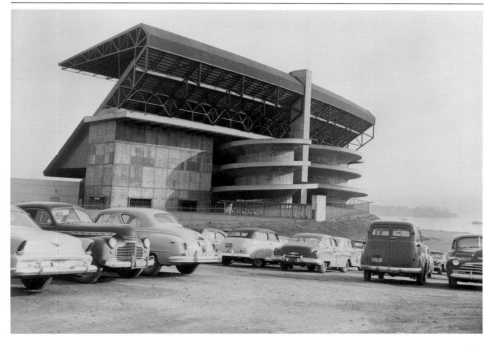

The University of Washington Shell House is best remembered as the training center of the "Boys in the Boat," the team that won gold at the 1936 Berlin Olympics. In this 1929 photograph, women pose with oars. In fact, there was no women's team that year, nor for some decades following. Given the decidedly unathletic clothes and shoes they wear, this may be a group of models. Today, the original Shell House is undergoing restoration, while the rowing crews operate out of a newer facility. (Courtesy MOHAI.)

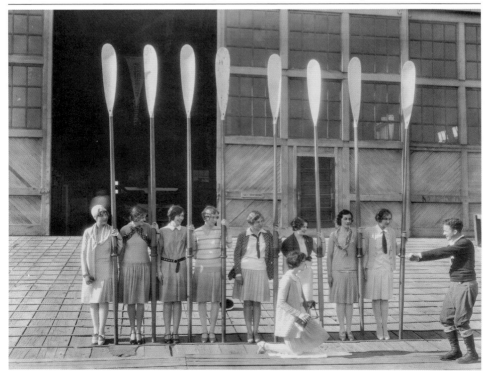

CHAPTER

2

THE WESTSIDE

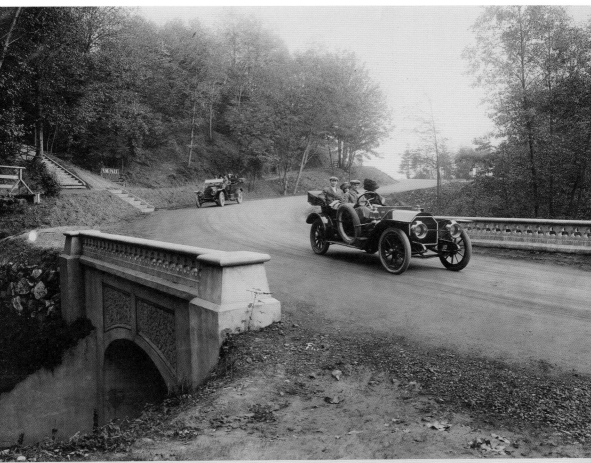

The west side of Lake Washington is largely defined by the plans of the Olmsted brothers. Beginning early in the 20th century, the Boston-based landscape firm designed a series of parks and green spaces along the lake shore connected by a scenic drive. This (probably staged) 1911 photograph shows touring cars on a serpentine section of Lake Washington Boulevard through Frink Park. (Courtesy SMA.)

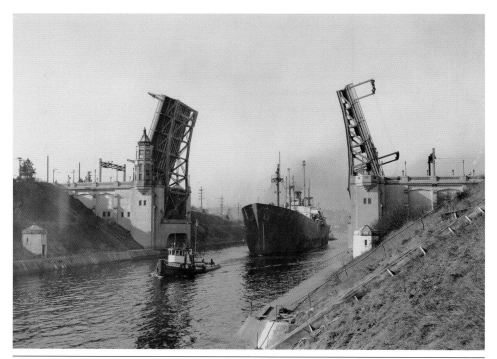

In 1916, the Army Corps of Engineers completed the Lake Washington Ship Canal project, which forever changed the geography and ecology of the lake. At its east end, the canal is often called the Montlake Cut for the neighborhood it slices through. The 1925 Montlake Bridge is a bascule drawbridge that opens to allow taller ships, like this freighter with tugs fore and aft, to move into the lake. Today's picture, facing west, shows the abundance of greenery that has grown up along the cut. (Courtesy USACE.)

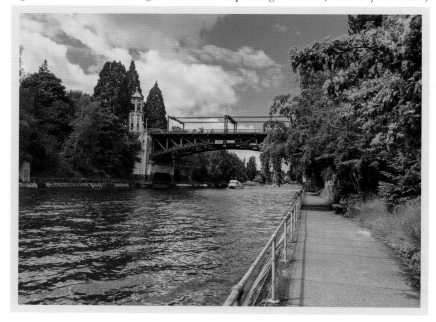

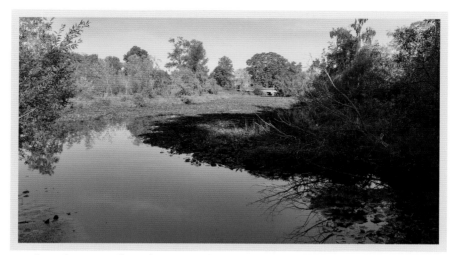

A man launches a small rowboat into the lagoon at Foster Island in the natural area that is now the Washington Park Arboretum. At the time of the 1912 photograph, there was no ship canal or freeway. Bisected by the Evergreen Point Floating Bridge, the seven-acre barely-an-island remains a peaceful place to wander and look for the "wild fosters." (Courtesy SMA.)

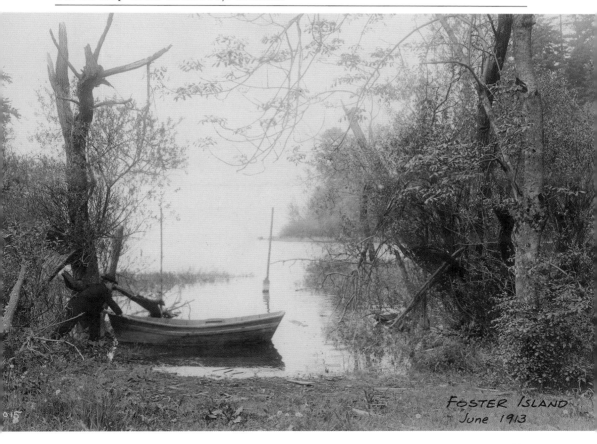

FOSTER ISLAND
June 1913

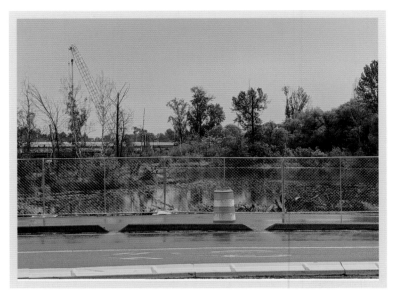

Teens take advantage of the "Ramps to Nowhere," remnants of a freeway that was never built. Construction of the crosstown R.H. Thomson Expressway was begun in the 1960s but became mired in opposition to its neighborhood- and park-destroying trajectory. Sections that were meant to connect the expressway to the floating bridge at the arboretum were allowed to stand for decades before finally being removed during bridge replacement in 2018. Some mourn the loss of the oddity. (Courtesy MOHAI.)

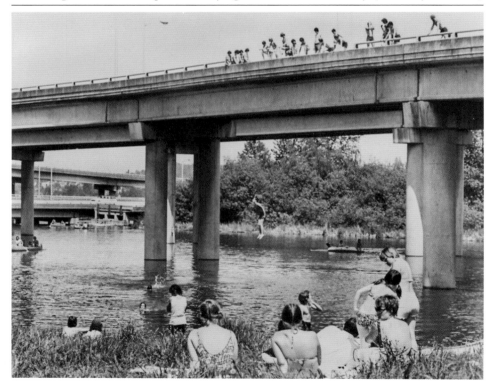

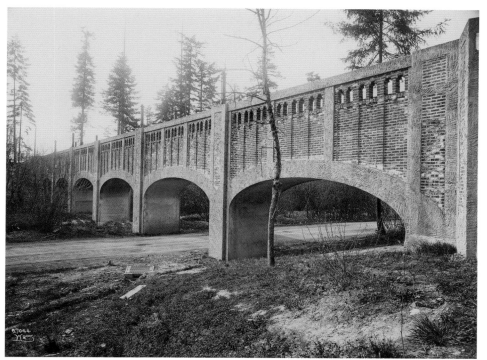

This arched brick bridge over Lake Washington Boulevard in the arboretum was designed to conceal a city sewer. At the time of this 1914 photograph, the span had been in place only a couple of years. The structure, sometimes called the Arboretum Aqueduct or Wilcox Footbridge (for the architect), provides a scenic pedestrian overpass and continues to serve King County Metro as a sewer viaduct. (Courtesy MOHAI.)

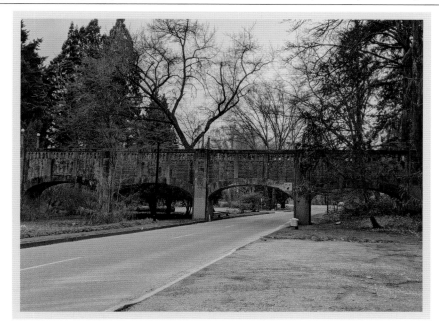

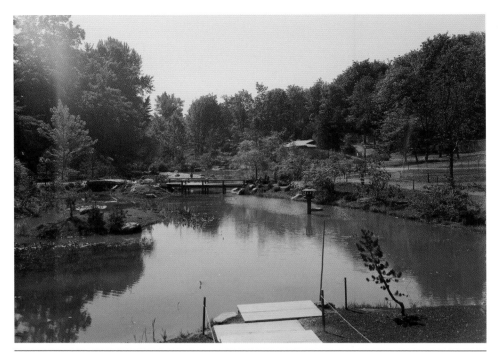

The Seattle Japanese Garden within Washington Park opened in 1960. It was designed primarily by Japanese landscape architect Juki Iida in the stroll garden tradition and built by Seattle contractor Richard Yamasaki and others. A comparison of the 1960 photograph and the 2020 repeat shows that the garden has grown into its bones. The teahouse, rebuilt in 1981 after an arson fire, can be seen at far right. (Courtesy UW.)

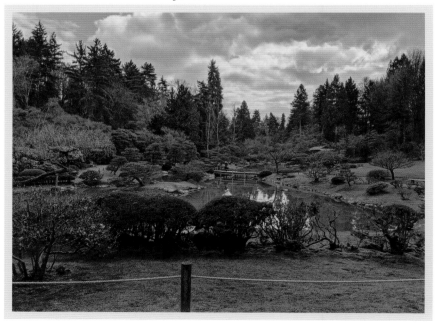

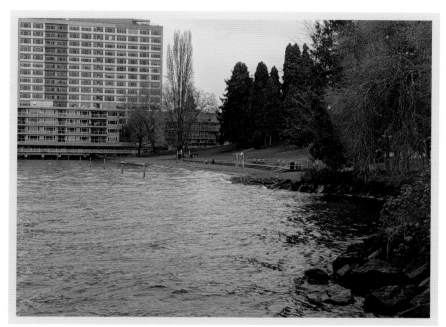

East of the arboretum, the neighborhood of Madison Park began as an amusement park for city folks who came down by cable car or crossed from the east side of the lake by ferry. By 1903, the date of this photograph, the park shore included picnic pavilions, a bandstand, a boathouse, and a baseball field. Today the beach area, surrounded by high-rises, remains popular on sunny days. (Courtesy SMA.)

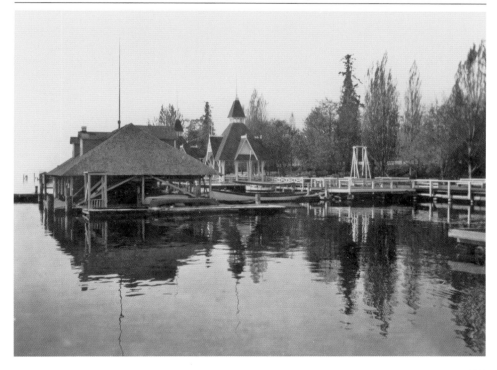

Leschi was another popular pleasure garden at the turn of the 19th century. Like Madison Park, the lakeside community took off as a result of cable cars and ferry service on the lake. In this 1906 image, folks wait for entertainment to begin. Judging by the clustered canoes, it is likely a musical performance. Today, Leschi boasts many lake-view condos and restaurants, as well as two marinas. (Courtesy MOHAI.)

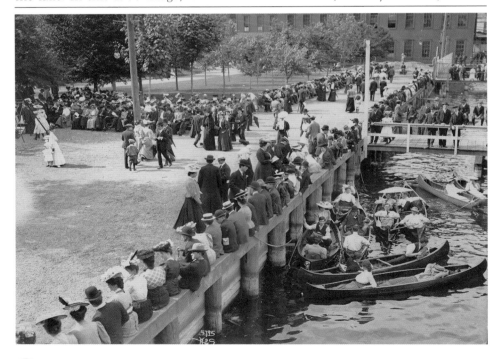

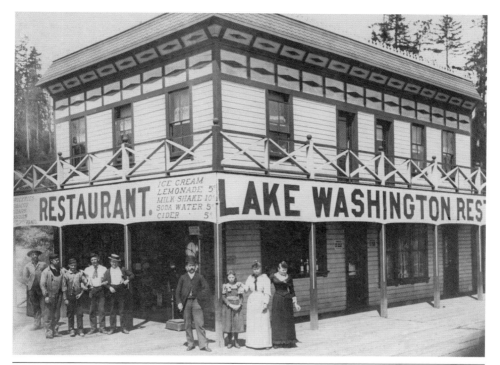

Immediately adjacent to the cable car landing, the 1896 Leschi Hotel and restaurant benefited from the crowds of city-dwellers who came to Leschi Park for cool breezes, recreation, and amusement. Today, the hotel site is part of a waterside complex of shops and restaurants including the BlueWater Bistro. (Courtesy Yousef Shulman.)

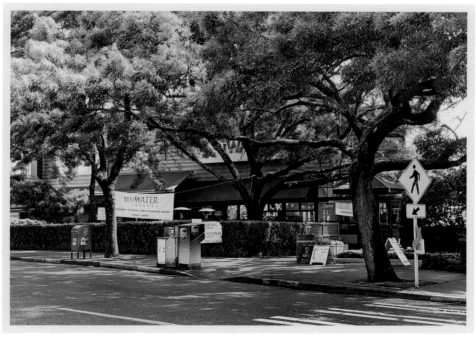

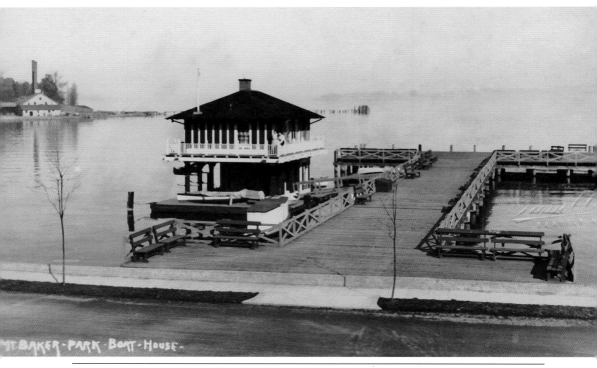

MT. BAKER · PARK · BOAT · HOUSE ·

The lake's western shore offers many spots for recreation thanks to the Olmsted plan. In addition to Madison Park and Leschi, day-trippers can visit Madrona Park, Frink Park, Colman Park, Mount Baker Park, Martha Washington Park, Pritchard Island, Brighton Beach, and numerous pocket parks, not to mention enormous Seward Park. The Mount Baker boathouse was built about 1908, the date of this photograph, to support small boat recreation. Caretakers lived in the second story. In 1949, the boathouse was replaced and transformed into a bathhouse for swimmers. (Courtesy RVHS.)

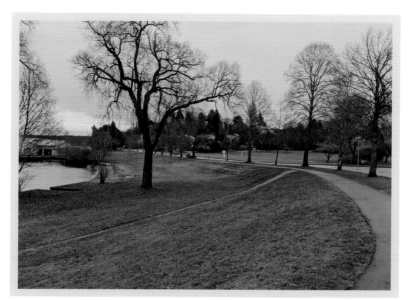

When Lake Washington Boulevard was first built, it ran on a bridge across the mouth of what was called Wetmore Slough and is now Genesee Park. The 1936 photograph shows the temporary dam constructed to hold back the lake waters while infilling took place in the slough. Today's photograph shows a section of the park on the right and the Mount Baker Rowing & Sailing Center at left, built on land reclaimed after the lowering of the lake. (Courtesy SMA.)

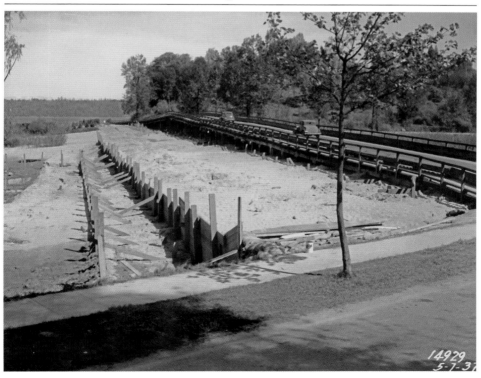

Several small marinas are scattered around the lake. A small boathouse was built in the Lakewood area early in the 20th century; it is pictured here in 1935. A larger one was constructed in 1953 and placed on a small island that appeared after the lowering of the lake. Ohler's Island was briefly home to a bird sanctuary in the 1930s. (Courtesy RVHS.)

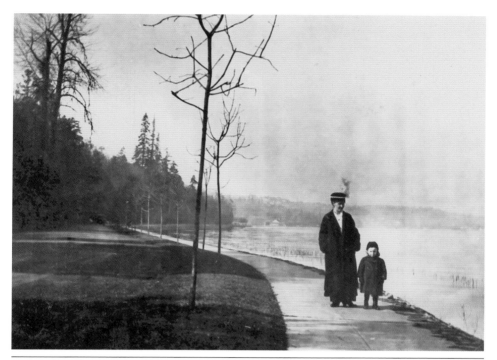

Footpaths follow most of the course of Lake Washington Boulevard. Here, Clara Ellen Davenport and her son, Howard, stroll along the shore near Andrews Bay on what must have been a chilly day in 1914. In the contemporary photograph, one can see a glimpse of the Mount Baker Rowing & Sailing Center at Stan Sayres Memorial Park at left. (Past image courtesy RVHS; present image courtesy Karen O'Brien.)

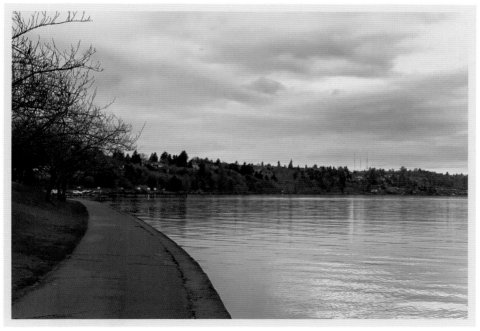

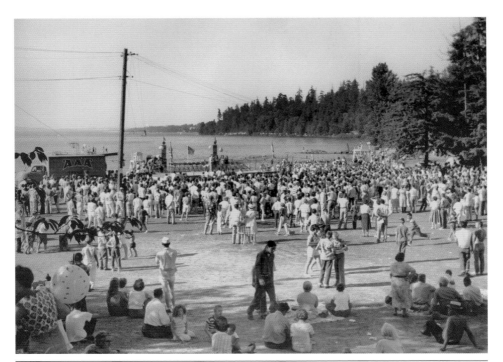

The crown jewel of the Olmsted plan for Seattle is Seward Park, a huge 200-plus-acre peninsula jutting into the lake that contains a quantity of old-growth forest. Many community events have been held at the park since it opened in 1911. Pow Wow, a precursor to Seattle's Seafair summer festival, was a big draw from 1934 to 1992. Here photographer Bill Templeton captures crowds watching what may be a swimming contest. Sadly, summer festivities in 2020 were canceled due to the Covid-19 crisis. (Courtesy John L. O'Brien family.)

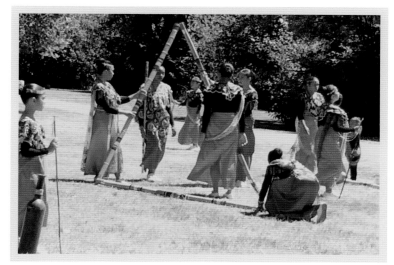

Many cultural groups turned to Seward Park for summer festivals. The Filipino community held an annual event here for many years under different names. In this 1960 photograph, from left to right, Virginia Ordona, Diana Floresca, and Theresa Ordona perform the Bamboo Dance, the Ordonas taking the male parts. In a more recent photograph, Filipina girls practice for a performance at Pista Sa Nayon (village festival). (Past image courtesy MOHAI; present image courtesy Karen O'Brien.)

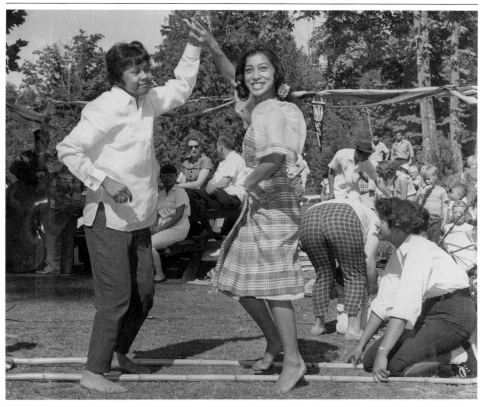

Pritchard Island was the site of a Native American longhouse in the 19th century. When the lake lowered, Pritchard Island lost its insular status. As the water fell, the sloughs separating it from the mainland drained away. The north end became a bathing beach; the south end is now a community farm and park. Posts for a World War II victory garden tended by the Gibbon family can be seen at the bottom of the photograph. Wetlands now cover the foreground of the 1940s image, making an exact repeat impossible. (Courtesy RVHS.)

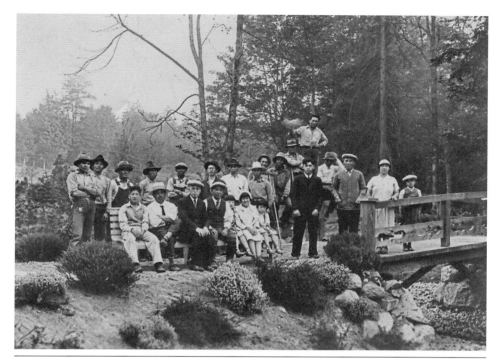

Japanese immigrant Fujitaro Kubota bought five acres of swampland in Rainier Beach in 1927 and established a landscape company as well as a large Japanese garden. Following World War II internment, the Kubotas were able to reclaim their property and rebuild their business. In 1981, the Kubota Garden was named a Seattle landmark; it is now a public park. The 1930 photograph shows the family and gardening crew on Heart Bridge. (Courtesy Kubota Garden Foundation and Densho.)

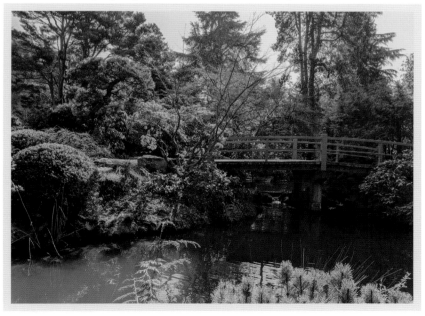

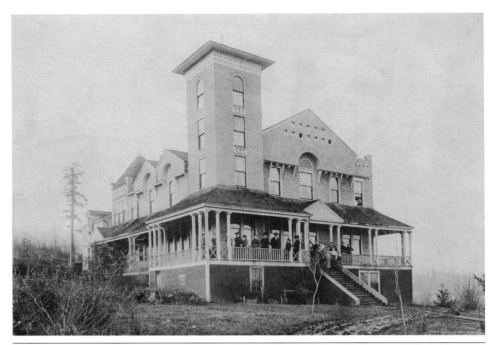

The mission of the Florence Crittenton Home in Seattle was the "founding, maintenance and conducting of a home and refuge for fallen women and the children thereof." Established in 1899 in this Victorian structure, the home for unwed mothers moved into a new brick building in 1926. Far from the city, and with views of the lake, the location was considered ideal for young women in seclusion. In 1973, the home closed; until recently, the building has been operated as a substance abuse treatment center. (Courtesy MOHAI.)

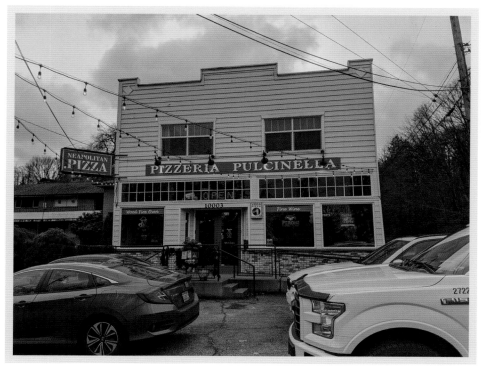

Taylor's Mill was one of the largest of the timber concerns that used the lake to transport logs and finished lumber. Built partly on piers extending from the shore, the mill was able to provide deep-water access for lumber schooners and steamships after the opening of the ship canal in 1916. Mill operations continued, under several owners, until about 1929. The only mill structure remaining today is the company store/post office, now an Italian restaurant in the Lakeridge neighborhood. (Courtesy RVHS.)

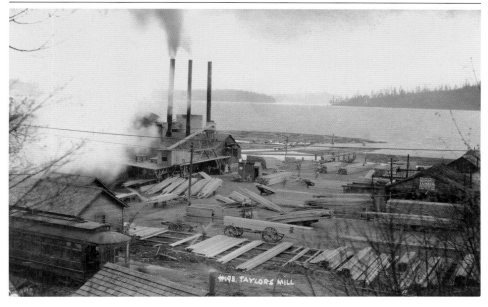

This bird's-eye illustration depicts Southeast Seattle with Lake Washington at right. Mercer Island is at far right, with smaller Pritchard Island toward the middle. Seward Park is seen extending into the lake at top, and Taylor's Mill is sketched in at bottom right. Since the lake lowering, much of the pictured bay is now wetlands, and Pritchard is no longer an island. The promotional, and somewhat imaginative, illustration was created after 1900 and before 1916. Mount Baker appears on the skyline. (Courtesy SMA.)

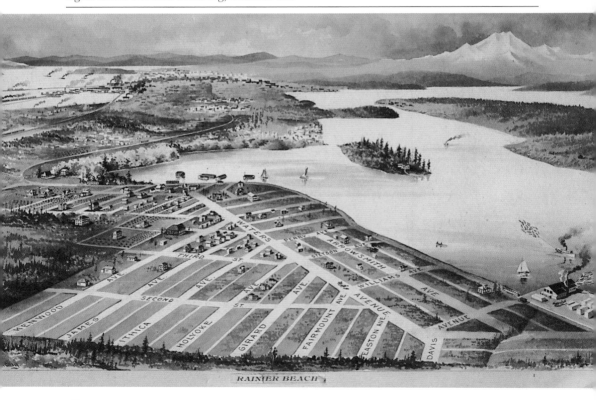

RAINIER BEACH

CHAPTER

3

THE SOUTH END

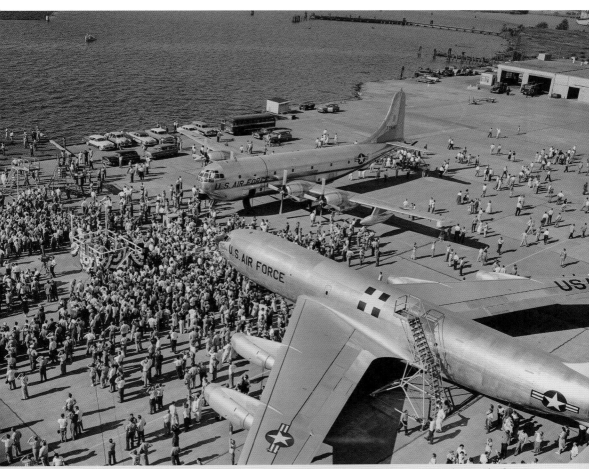

The city of Renton sits at the southern end of Lake Washington. Beginning in the late 19th century, the south shore became a center for industries, including natural resource extraction, manufacturing, and energy.

Today, Boeing and Kenworth Trucks have large plants here alongside big-box stores and traditional retail. (Courtesy MOHAI.)

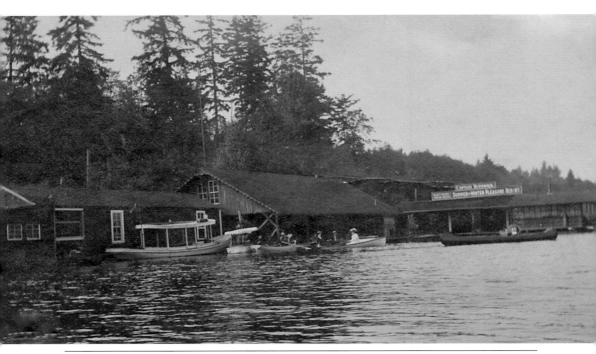

After the lake lowering, the Black River outflow at Renton dried up, taking its salmon run with it. Captain Burrow's Pleasure Resort lost its reason for being. The c. 1900 photograph shows canoes, rowboats, and a launch ready for anglers. Today, due to dredging and channelization, the Cedar River flows into the lake at nearly the same spot. The modern image was taken from a shoreline park between the Renton Municipal Airport and the Boeing Renton Factory; a bridge suitable for airplanes connects the two over the river. (Courtesy RHM.)

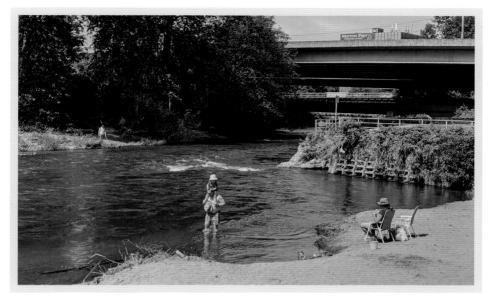

More than 300 youngsters participated in Renton's Kids Fishing Derby on June 12, 1949. The Cedar River was fully stocked with trout for the occasion. A double bridge spans the river, one for traffic, one for the railroad. The location of both photographs is Liberty Park. Harvey Davis may have taken the 1949 photograph from a third bridge; many continue to span the Cedar as it makes its way to Lake Washington. (Courtesy MOHAI.)

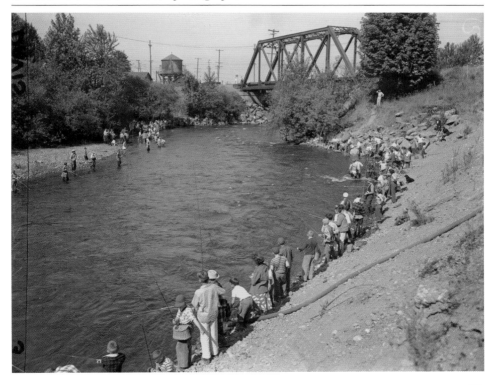

Years ago, the shoreline now known as Gene Coulon Memorial Beach Park was Lake Washington Beach Park or simply "the beach." Before the lake was lowered, the rail tracks ran much closer to the shore. In the photograph, the passenger ferry *Valdez* can be seen on its run between Rainier Beach and Kennydale. Coulon Park, with its meandering trails, swimming beach, and modern facilities, was dedicated in 1982 and named for the Renton parks director who envisioned it. (Courtesy RHM.)

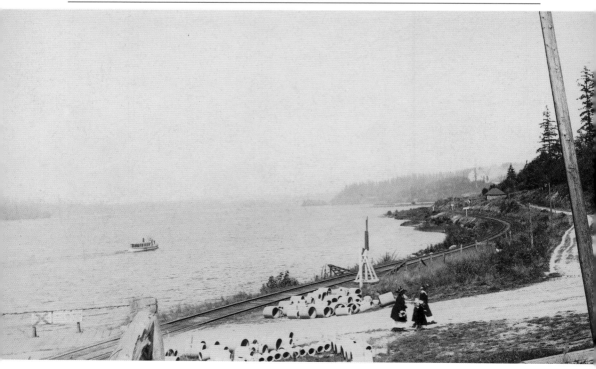

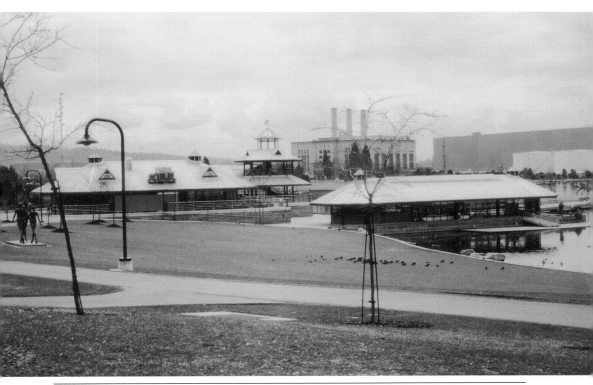

The 2020 shot of Coulon Park in Renton at first glance appears quite similar to that of 1985. However, on closer inspection, one sees that the massive Shuffleton hydroelectric plant, which dominated the lake's south shore for seven decades, is gone, imploded in 2002 to make way for a luxury hotel and high-rises. The Boeing plant still operates, inches from the new development called Southport. (Courtesy RHM.)

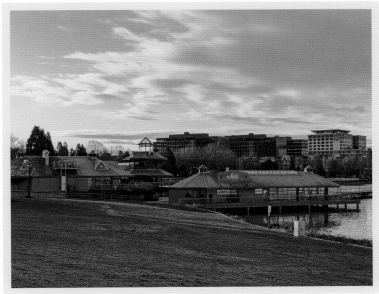

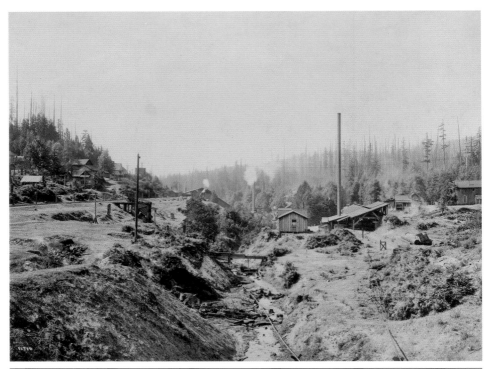

Coal was king for large stretches of the southeast quadrant of Lake Washington and hinterlands, as testified in names such as Coal Creek, Newcastle, Coalfield, and Black Diamond. The Coal Creek mine and sawmill were five miles from the lake shore via the creek or three miles by dirt road. The mine relied on the lake for transporting coal to market before rail service around the lake was established in 1870. Today, trails run through the ravine past relics of the mining operation and town. (Courtesy MOHAI.)

Art Wood recalled Prohibition days in Newcastle: "They had stills up along May Creek. You could walk out on that great big wooden trestle at night and look down the canyon and see little charcoal fires twinkling. They'd run the booze down into the water in gunny sacks. When the revenooers raided, they couldn't find it and it was kept cool in the lake." In the 1932 photograph, children return from berry picking about the time the 138-foot-high structure was abandoned by the railroad and the area returned to nature. (Courtesy MOHAI.)

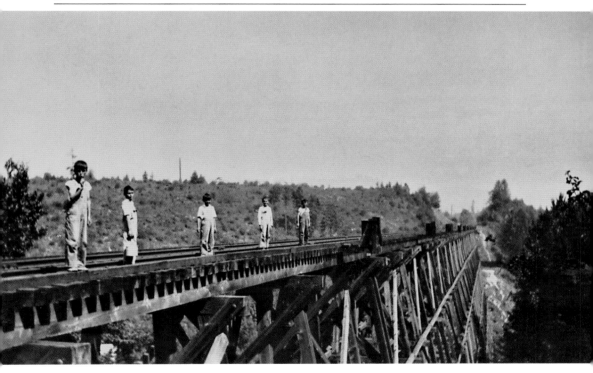

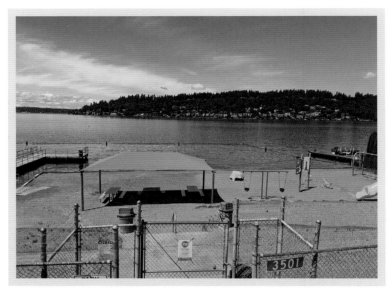

Dail Butler Laughery remembered the community of Kennydale, seen in an undated photograph, during the Great Depression: "When I was about ten years old, we were picking wild blackberries and we stopped to get a drink at a lively, crystal clear little spring. There was a grove of trees to the left of the road on the beach of Lake Washington and there we saw three men squatted around a campfire, cooking something in tin cans, which they stirred from time to time." In the spring of 2020, the small beach was closed due to the Covid-19 crisis. (Courtesy RHM.)

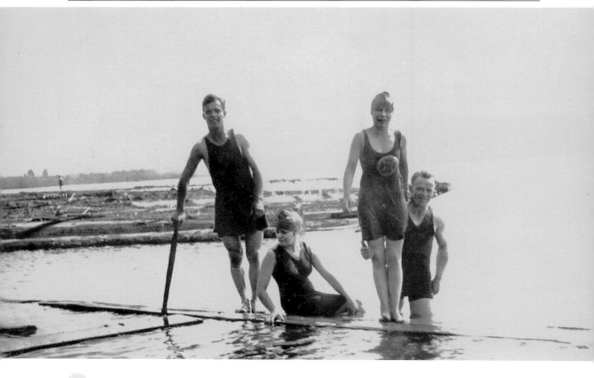

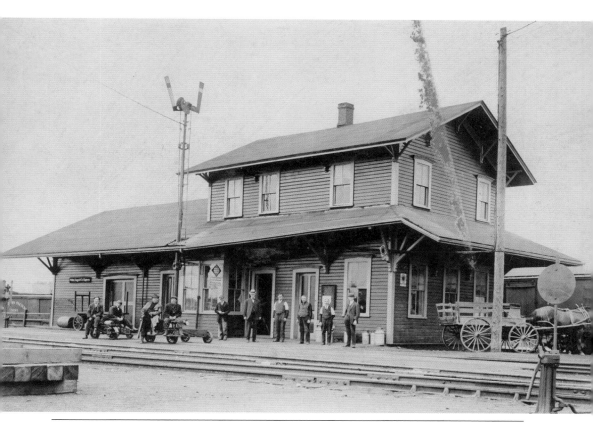

The current Renton rail depot, constructed in 1952, is the third station built in the town. Over the decades, it has served the Milwaukee Road and Burlington Northern rail lines alongside local trains. From 1993 to 2007, it was home to the Spirit of Washington Dinner Train, a popular excursion up the east side of the lake to a Woodinville winery. Today, the depot houses a visitor center and the Renton Chamber of Commerce. The original 1886 depot is pictured in the 1920s. (Courtesy RHM.)

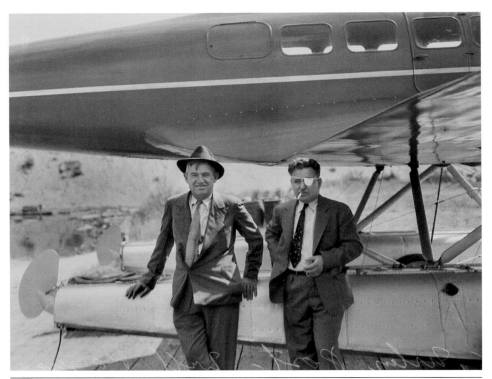

When one-eyed aviator Wiley Post and humorist Will Rogers died in a plane crash at Point Barrow, Alaska, on August 15, 1935, it was a national tragedy. Their final journey began a week earlier at the Renton/ Bryn Mawr Airport. While waiting for their plane to be fitted with pontoons, the famous pair greeted fans and reporters. A couple of lucky fellows were invited along on a test flight over the lake. In 1949, a lakefront section of the airport was christened the Will Rogers–Wiley Post Memorial Seaplane Base. (Courtesy MOHAI.)

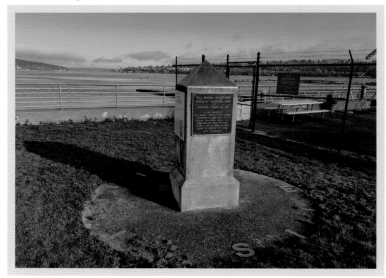

CHAPTER **4**

THE EASTSIDE

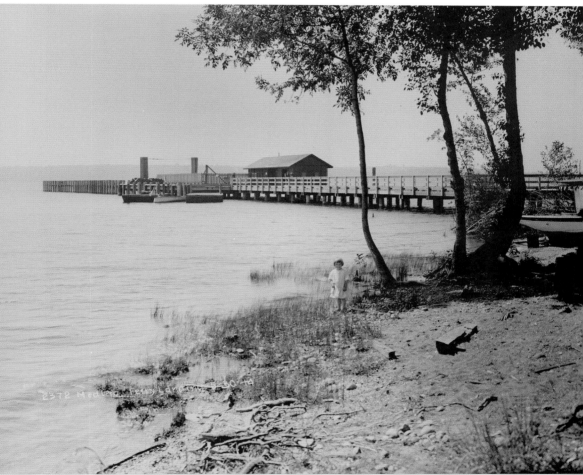

Following an era of farming and orchards, much of the lake's east side was developed as suburban housing. Not surprisingly, much of the shorelands with a view became enclaves for the well-heeled, including Medina, Hunts Point, Yarrow Point, and Newport Shores. The Medina ferry landing is pictured in 1914. (Courtesy SMA.)

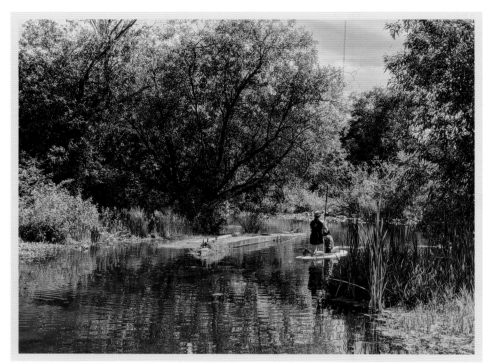

Before the lowering of the lake in 1916, Mercer Slough was a much wider and deeper channel, suitable for both commercial and recreational navigation. Today, the City of Bellevue maintains the wetland complex as the Mercer Slough Nature Park. The 1910 photograph shows a party enjoying an idyllic boat ride; the current image, taken at the Sweylocken Boat Launch, includes paddleboarders and ducks in the shallow remnant of the waterway. (Courtesy EHS.)

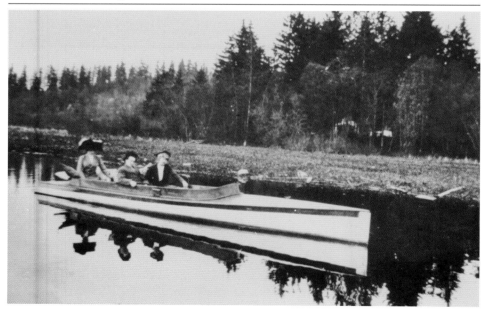

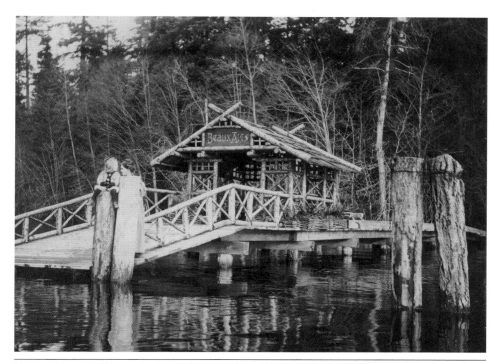

Beaux Arts Village is King County's smallest incorporated town. It consists of 50 acres, with a population of less than 300, completely surrounded by Bellevue. The tiny settlement on the lake shore was founded in 1909 by a group of artistic-minded folks who envisioned a utopian colony. This c. 1910 photograph shows the rustic ferry landing, the only ready access to the colony until the first floating bridge was opened in 1940 just to the south. The lowering of the lake pushed the shoreline westward. The modern photograph was taken from a small park just north of the village. (Courtesy MOHAI.)

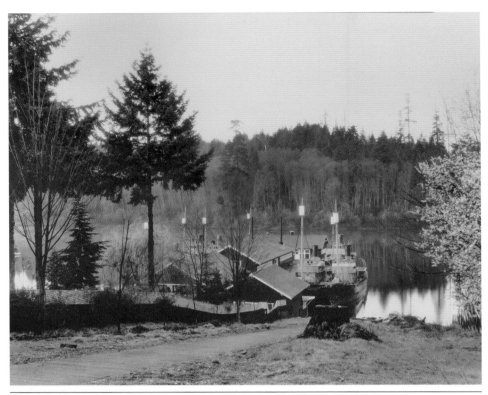

Meydenbauer Bay was the first settled area in what is now the ultramodern city of Bellevue. From 1919 until World War II, the boats of the American Pacific Whaling Company overwintered here while preparing for the summer whaling season in Alaska. The ship canal made it possible for the vessels to access freshwater moorage in Lake Washington. In 2019, major improvements were made to Meydenbauer Bay Park. (Courtesy MOHAI.)

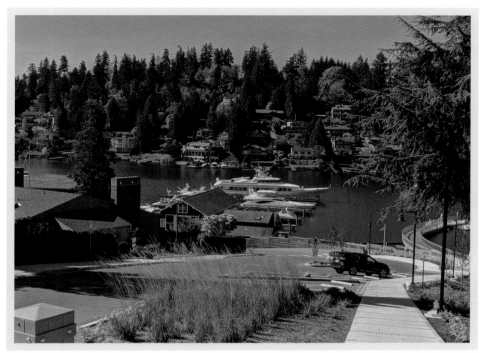

Today, a couple of historic dock buildings still stand on Meydenbauer Bay in Bellevue between a marina and a public park. A luxury yacht is one of many types of vessels that ply the waters of Lake Washington. Ferries, however, are gone for now, replaced by two floating bridges. In this 1914 photograph, the *Leschi*, the first car ferry on the lake, is docked at the landing on the bay. A horse-drawn buggy stands ready to board along with a horseless carriage. (Courtesy PSMHS.)

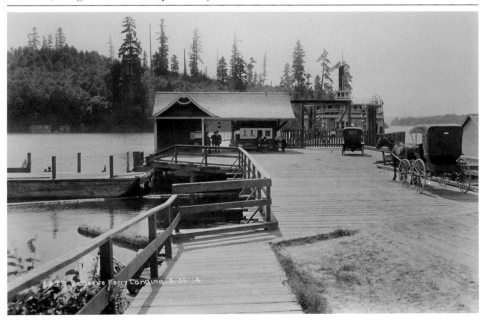

Kirkland's high-end commercial development Carillon Point was for many years a shipyard in the community called Houghton. With boatworks roots going back to the 1870s, the Lake Washington (or Anderson) Shipyards made headlines as the birthplace of the art deco ferry *Kalakala* in 1935. In this 1918 photograph, crowds await the launching of a steamship. Today, the trendy marina has a much different look and feel. (Courtesy MOHAI.)

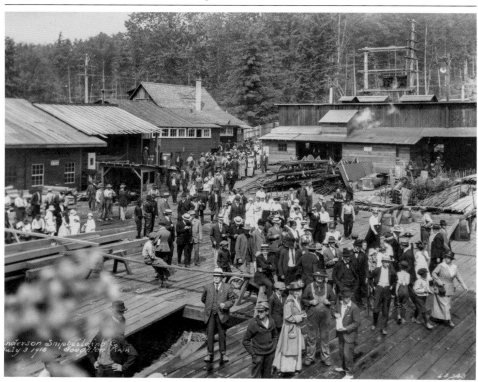

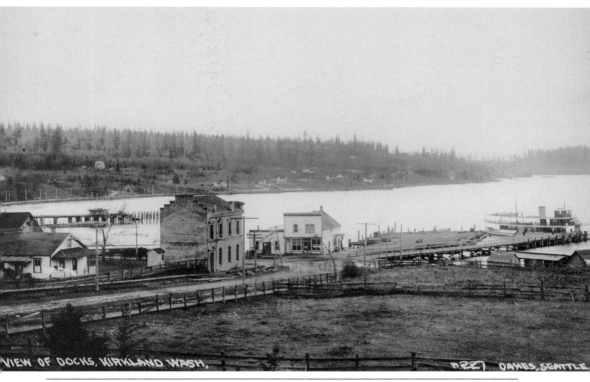

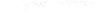

VIEW OF DOCKS, KIRKLAND WASH. #227 DAWES, SEATTLE

The town of Kirkland boasted two ferry docks around 1909: the one in the foreground was privately run, while the one at left served King County ferries. In the contemporary photograph, the ferries are long gone, and yachts and pleasure boats obscure most of the marina's dock. (Courtesy MOHAI.)

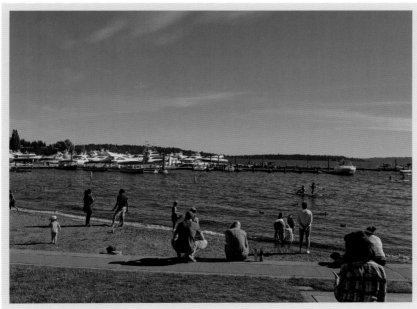

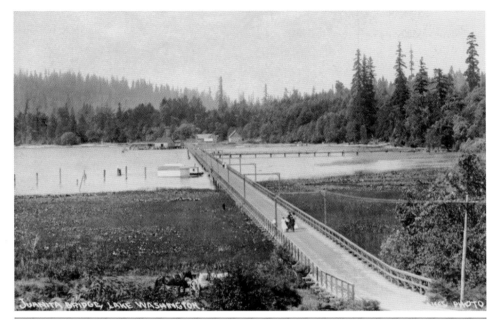

A series of pedestrian bridges have crossed the inlet of Lake Washington called Juanita Bay on the north side of Kirkland. This c. 1910 photograph shows the wooden bridge before the lowering of the lake a few years later. Today's bridge crosses over wetlands created when the bay shrank back. It bisects Juanita Bay Park, a large nature preserve that was once a golf course. (Courtesy MOHAI.)

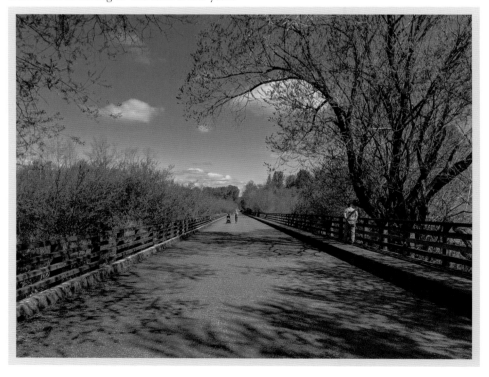

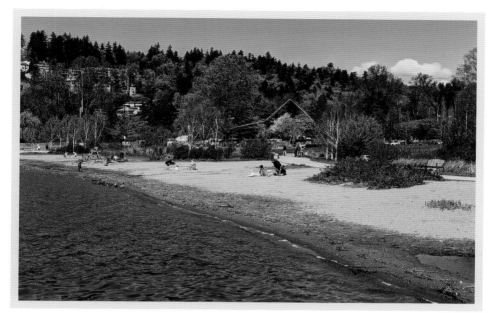

Juanita Beach has been a destination for both Eastsiders and Westsiders since the 1920s. The lowering of the lake in 1916 revealed a wide beach at Juanita Bay and shallow water perfect for swimming. First opened as a resort by a local family, the beach has expanded over time and several owners. It is now a City of Kirkland park. The photograph from the 1930s shows the old bathhouse, constructed in 1928. In 2020, a new bathhouse is under construction. (Courtesy MOHAI.)

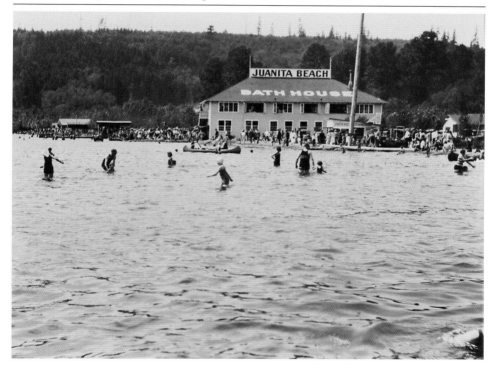

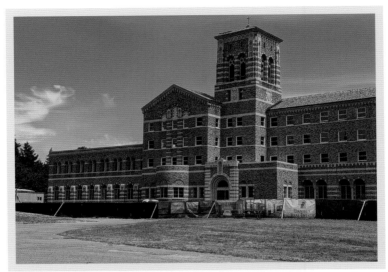

In the 1920s, the Seattle Catholic Archdiocese chose a forested tract overlooking Lake Washington in Kenmore to establish a seminary where young men would train for the priesthood. The photograph shows the dedication ceremony of St. Edward Seminary on October 13, 1930. The school closed in 1976. After languishing for several decades, the Romanesque Revival structure is being repurposed as a hotel and conference center. In the meantime, the 326-acre grounds, including a small swimming beach, became St. Edward State Park. (Courtesy Archives of the Archdiocese of Seattle.)

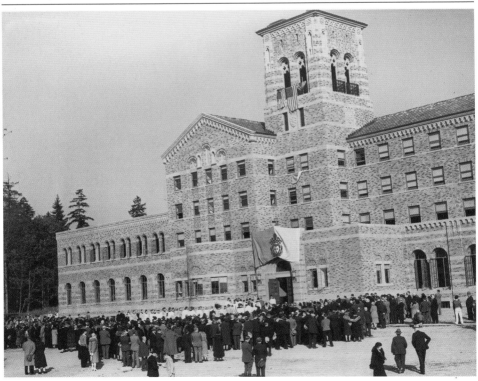

GETTING AROUND

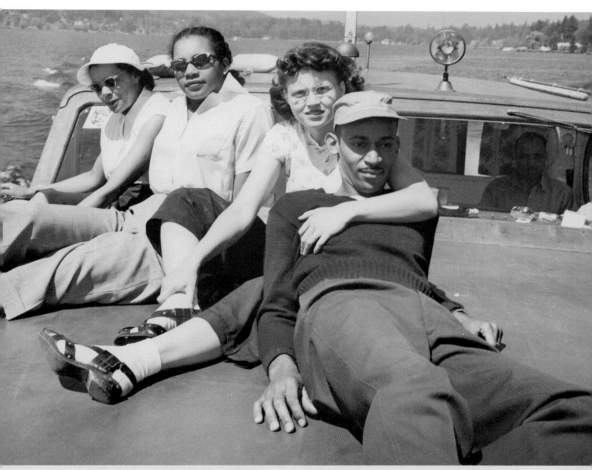

When explorer Isaac Ebey first set eyes on Lake Washington (which he named Lake Geneva) in 1850, it was from a canoe, about the only method of freshwater transportation available at the time. Since then, the waters have seen a multitude of vessels from rowboats to steam-powered ferries to many types of workboats. Here, a group of friends enjoys pleasure boating on Union Bay about 1950. (Courtesy BHS.)

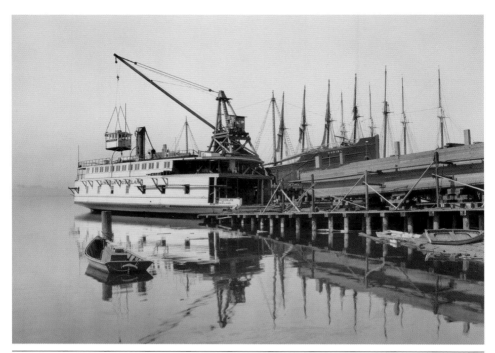

By the 1920s, the lake saw larger ferries with car service. A fleet of county-run ferries included the *Lincoln of Kirkland*, shown here undergoing repair at the Anderson Shipyard in Kirkland about 1923. A forest of masts behind the ferry indicates the presence of sailing ships, including the four-masted *Muriel*. It is likely that *Muriel* is undergoing retrofitting as a Spanish galleon for her upcoming role in the 1924 version of *The Sea Hawk*. Today, pleasure boats fill the basin that was once a bustling shipyard. (Courtesy MOHAI.)

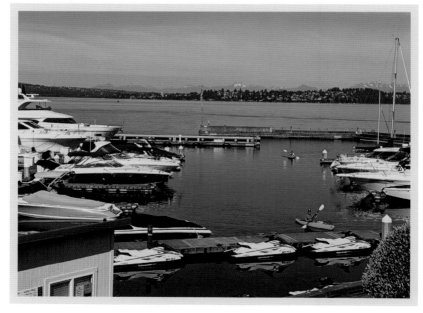

Before the days of the floating bridges, many ferryboats carried passengers across the lake. Just about every community on the lake had a dock. Roanoke Landing on Mercer Island, in this undated picture with the ferry *Fortuna*, served folks headed to and from the community called East Seattle on the lake's biggest island. Today, it is one of a number of landings turned into street-end parks, this one boasting a dynamite view of Bellevue. (Courtesy PSMHS.)

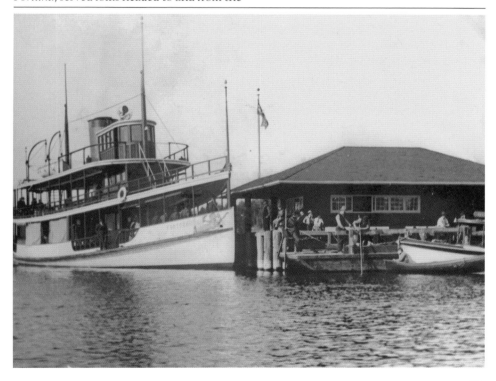

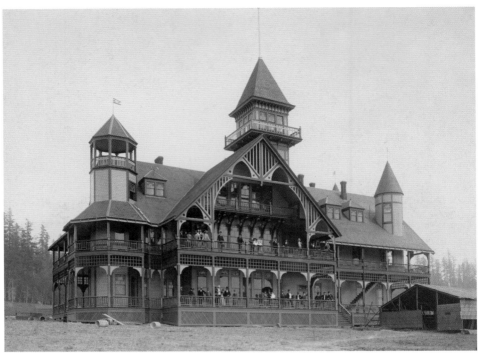

Mercer Island is a six-square-mile landmass at the south end of the lake that today is largely residential. The Calkins Hotel, shown here the year it opened in 1890, was a destination resort for only a few years. Later, it was briefly a sanitarium offering to cure nervous maladies. Ads promised "charming boat rides on Lake Washington and beautiful walks through the forest." The building burned down in 1908. (Above, courtesy MOHAI; right, courtesy WSHS.)

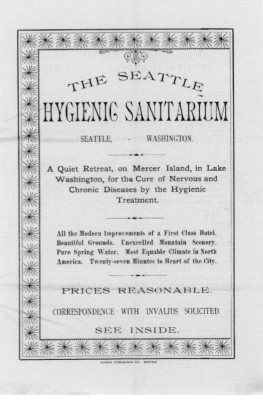

THE SEATTLE

HYGIENIC SANITARIUM

SEATTLE, · WASHINGTON.

A Quiet Retreat, on Mercer Island, in Lake Washington, for the Cure of Nervous and Chronic Diseases by the Hygienic Treatment.

All the Modern Improvements of a First Class Hotel. Beautiful Grounds. Unexcelled Mountain Scenery. Pure Spring Water. Most Equable Climate in North America. Twenty-seven Minutes to Heart of the City.

PRICES REASONABLE.

CORRESPONDENCE WITH INVALIDS SOLICITED.

SEE INSIDE.

LEADER PUBLISHING CO., SEATTLE

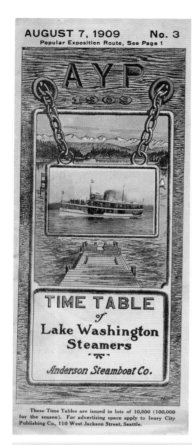

A special timetable was printed for folks wanting to visit the Alaska-Yukon-Pacific Exposition (AYPE) in 1909. The booklet offers a map of locations around the lake, including Mercer Island, where passengers could catch a steam ferry to the fairgrounds on the grounds of the University of Washington. The contemporary photograph shows the small beach called Calkins Landing, site of the old hotel and sanitarium. (Courtesy WSHS.)

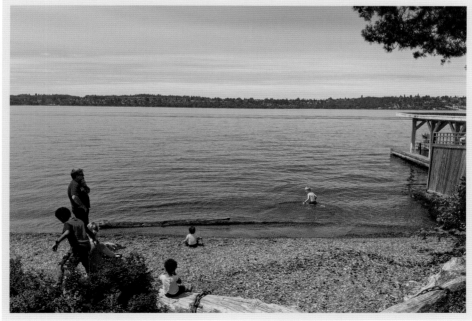

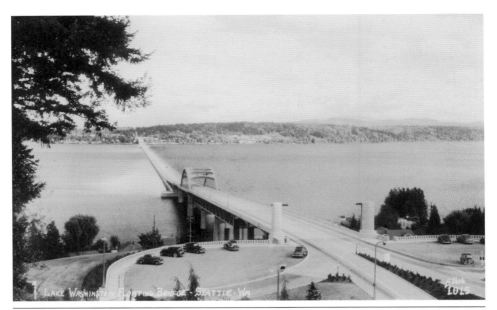

The first floating bridge across Lake Washington opened in 1940, supported by giant pontoons. On Thanksgiving weekend in 1990, following a big storm, the Lacey V. Murrow Bridge broke apart and sank. Luckily, a parallel span was under construction at the time. Today, both the rebuilt Murrow Bridge and the Homer Hadley Bridge carry traffic along Interstate 90 between Seattle's Mount Baker neighborhood and Mercer Island. A non-floating bridge continues on to Bellevue. (Courtesy WSHS.)

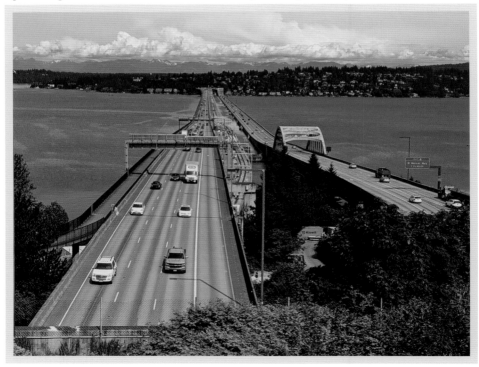

A second floating bridge was completed in 1963 north of the original, connecting Northeast Seattle to several communities, including Bellevue and Kirkland. The Evergreen Point Bridge takes its name from the first neighborhood it reaches on the Eastside. In 2016, a brand-new bridge was officially opened to traffic, but work on the span and its approaches continues. It is the longest floating bridge in the world; the I-90 bridges come in second. (Courtesy MOHAI.)

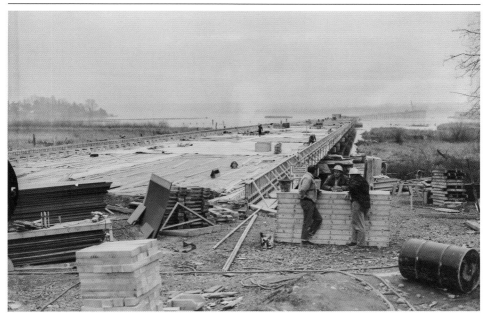

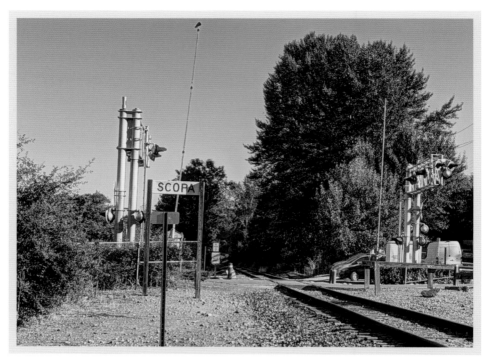

Railroads and streetcars once circled Lake Washington carrying both passengers and freight. Here in 1951, a Pacific Coast locomotive, piloted by a brakeman, returns from what was probably the Scott Paper (Scopa) log dump in what is now Gene Coulon Memorial Beach Park in Renton. The crossing sign still stands, a relic. Tracks still run at level ground through Renton's downtown, with freight trains carrying whole fuselages into the Boeing plant. However, north of Coulon Park, rails are being converted to a bike/pedestrian path sometimes called Eastrail. (Courtesy Pacific Northwest Railroad Archive; photographer Albert Farrow.)

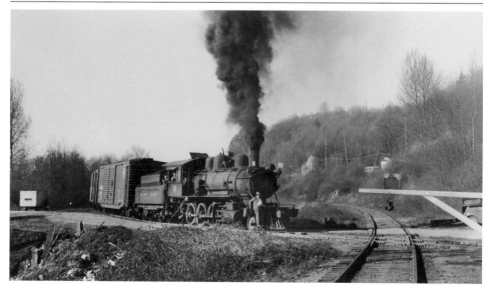

GETTING AROUND

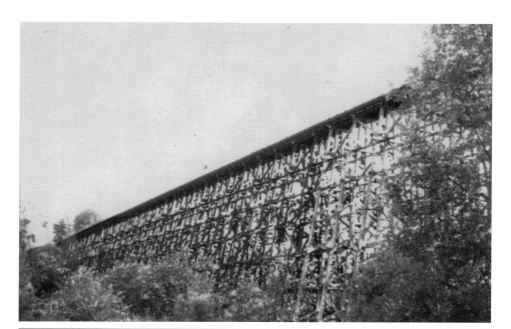

Not for the faint of heart, the 100-foot-tall Wilburton Trestle was built about 1904 to serve the Hewitt-Lea/Wilburton lumber mill in Bellevue by allowing railcars to cross the Mercer Slough on their way to the lake. Eventually, the trestle became part of the Eastside rail corridor. Today, plans are afoot to integrate it into the Eastrail pathway. (Courtesy EHS.)

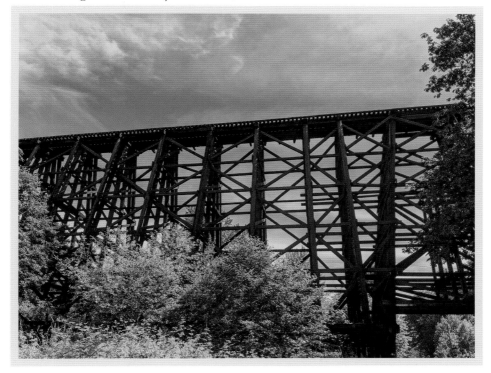

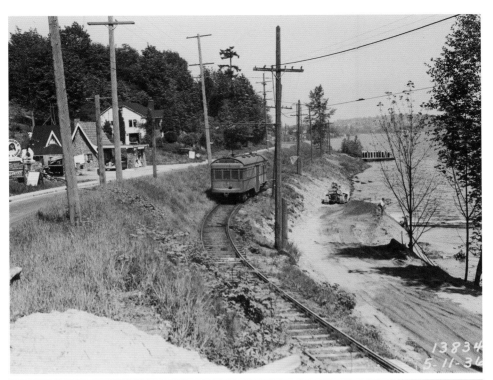

A relic of the automobile age, the Stone House Café began life as a service station on Lake Washington Boulevard between Seattle and Renton. This 1936 photograph offers a snapshot of changing times, as the Seattle-to-Renton trolley makes one of its last runs on tracks soon to be torn up. Meanwhile, the Seattle Engineering Department is grading land exposed by the lake lowering to plat for housing. In today's photograph, road work continues, this time stabilizing the hillside. (Courtesy RVHS.)

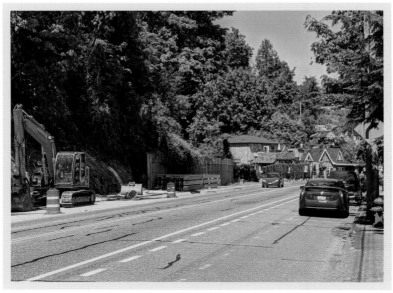

For a few brief years, 1938–1941, Pan American Airways operated service to Alaska using Sikorski S-42 flying boats. Remarkably, the Alaska Clippers took off from a small beachfront on the northwest shore of the lake. The photographer was standing on what is now private property; today's photograph, complete with heron, faces south from the edge of Matthews Beach Park. True to their name, these overgrown seaplanes could land on water. The clipper pictured was destroyed at Hong Kong by Japanese bombs just a few hours after the attack on Pearl Harbor. (Courtesy MOHAI.)

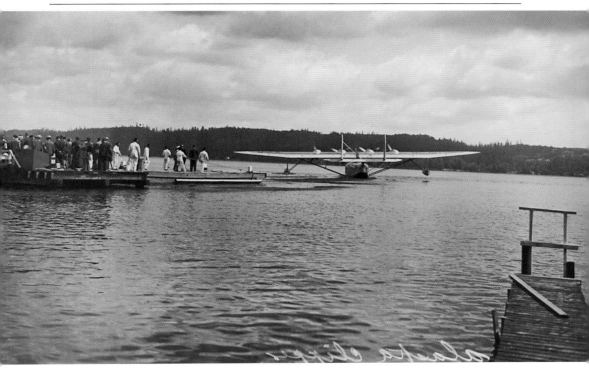

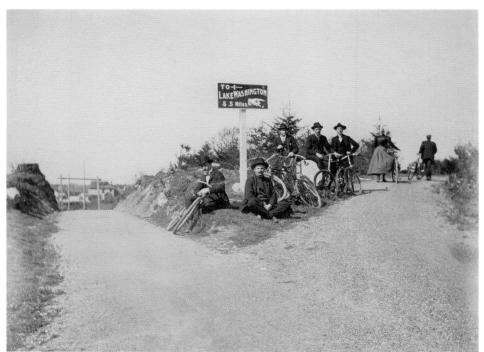

Biking was a craze a century ago, as it is again today. Here, a group of cyclists takes a break on a bike path headed to Lake Washington over Seattle's Capitol Hill about 1900. Beginning in the 1970s, proponents of cycling turned their eyes to abandoned and little-used railroads. This c. 1975 brochure promotes conversion of an early rail corridor between Seattle and Kenmore for recreation. (Above, courtesy MOHAI; right, courtesy SMA.)

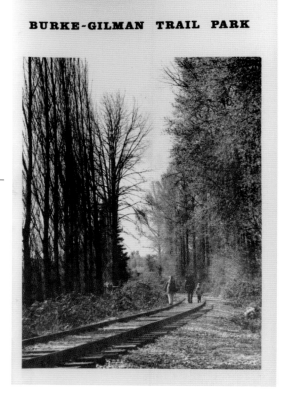

BURKE-GILMAN TRAIL PARK

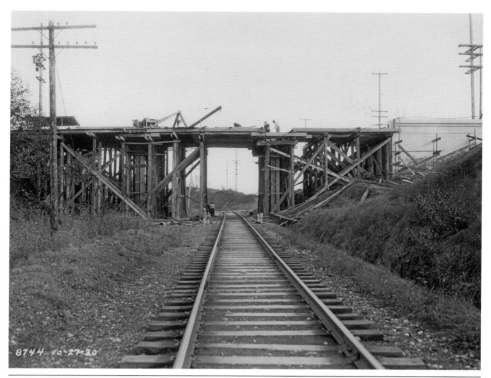

Most of the railroads that circled the lake have been converted to recreational use for hikers and bikers. The 1930 photograph shows the Princeton Avenue Bridge in Northeast Seattle under construction over the tracks of the Seattle, Lake Shore & Eastern Railroad. In 1978, this right of way was transformed into the popular Burke Gilman Trail, thanks largely to grassroots organization. (Courtesy SMA.)

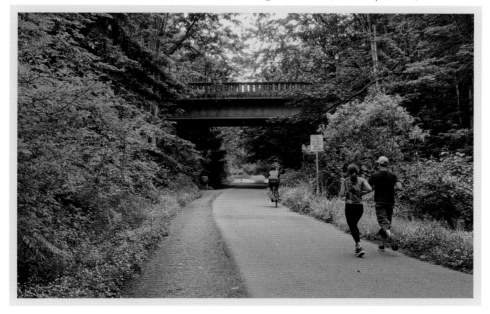

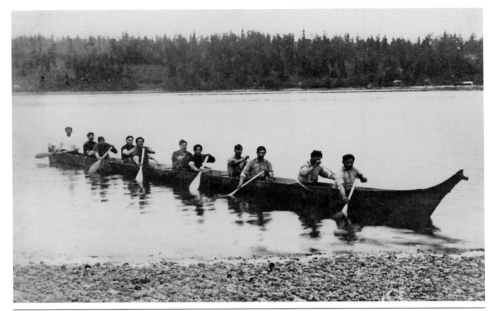

Members of the Squamish tribe participate in a canoe race on Portage Bay at the AYPE in 1909. The world's fair was held on the grounds of the University of Washington between the lake and the bay. At the time, only a narrow channel connected the two bodies of water. A few years later, the ship canal was dug through the portage that separated them. Today, human-powered watercraft, including canoes, kayaks, and paddleboards, share the waterway with ducks, geese, and motorboats. (Courtesy MOHAI.)

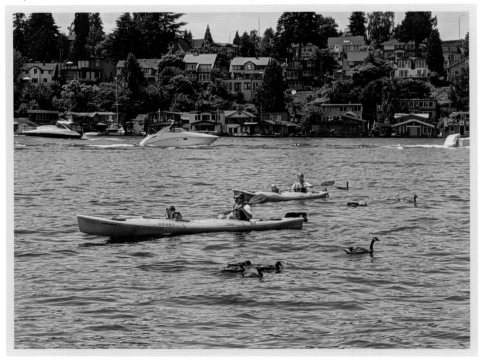

GETTING AROUND

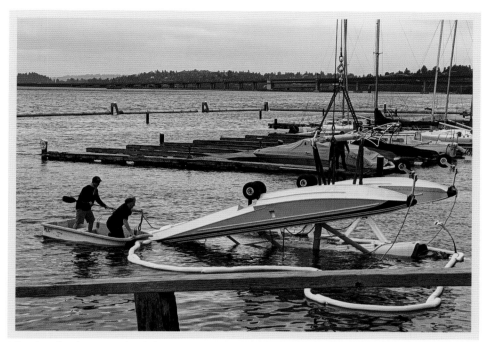

This lovely photograph of the I-90 floating bridge and Mount Rainier was probably taken from the Leschi neighborhood in the early 1940s. Tugboats *Norene* and *Gilman* stand at the dock. In the 2020 photograph, a salvage crew works to hoist out a seaplane that has capsized in the lake. The bridge is, of course, the reconstructed span. Alas, Mount Rainier disappears in the grey skies. Amazingly, the 1906 *Norene* still sails Puget Sound waters. (Courtesy EHS.)

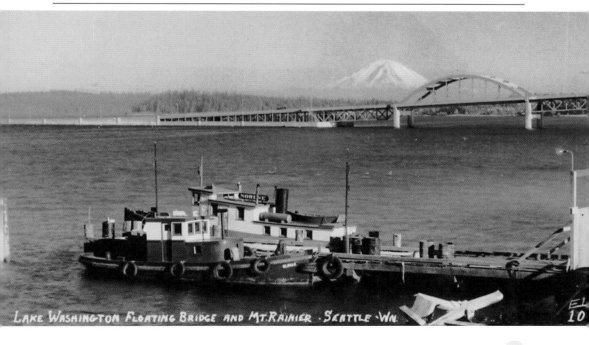

LAKE WASHINGTON FLOATING BRIDGE AND MT. RAINIER · SEATTLE · WN.

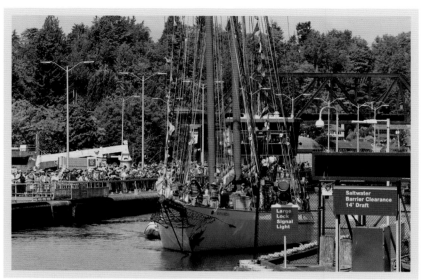

Although the Lake Washington Ship Canal was not completed until 1917, some vessels began using the locks a year earlier. Here, the launch *Orcas* and the snagboat *Swinomish* are the first to transit the locks, on August 3, 1916. The canal changed transportation and commerce forever, making it possible for lumber and coal barges, as well as tall ships and ferries, to travel directly from freshwater lakes to Puget Sound. The 2017 photograph shows the tall ship *Adventuress* entering the locks during the Centennial Boat Parade commemorating the official opening of the locks. (Past image courtesy USACE; present image courtesy Kyle Stetler.)

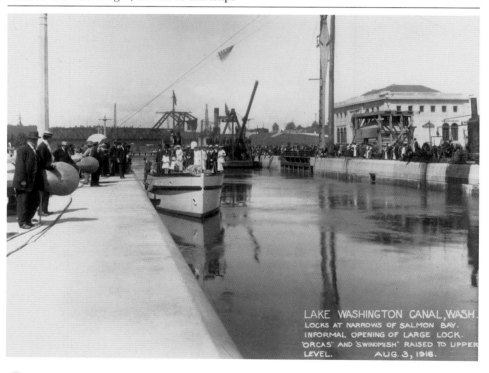

ECOLOGY OF THE LAKE

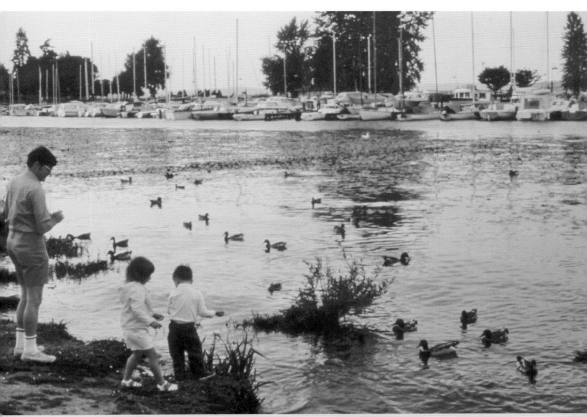

A family feeds ducks at a Lake Washington marina about 1970. For over a century, the lake has suffered the effects of rapid urbanization while also undergoing man-made reengineering. Waters once pure enough to drink, which provided habitat to many wildlife species, have been used as a cesspool for sewage, stormwater, and industrial pollutants. Fortunately, in recent decades, steps have been taken to clean up the lake. (Courtesy NARA.)

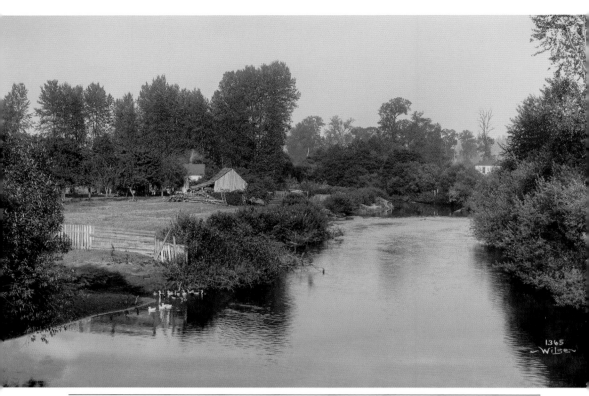

The Black River, seen around 1898 above and below in 1916, was a casualty of the opening of the ship canal. As the lake waters funneled out through the cut, the old lake outlet dried up and disappeared. Morda Slauson wrote to her fellow historian Lucile McDonald in 1969, "The most disastrous thing that happened was the wiping out of an entire salmon run. I have had many Renton folks tell me how sad it was to watch the beautiful Black River turning into a mud hole." (Above, courtesy MOHAI; below, courtesy RHM.)

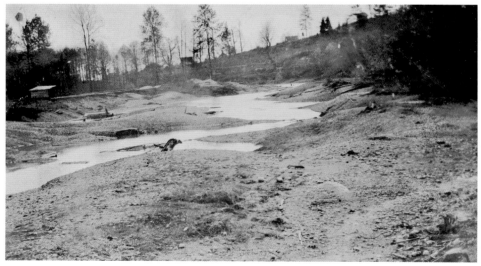

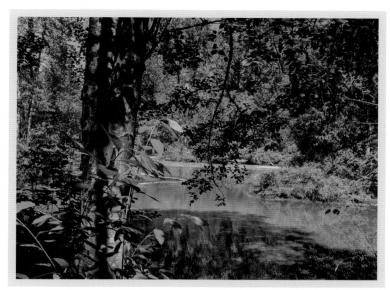

Anna Jorgensen Tonkin described the Black River to historian Morda Slauson: "It was a beautiful river with clear, still pools. The banks were covered with ferns, flowers and wild shrubs. We children loved to watch the Indian canoes go by with their paddles rising and falling in perfect rhythm." The photographs show the river about 1898 and the remnant today in the Black River Riparian Forest in Renton. (Courtesy MOHAI.)

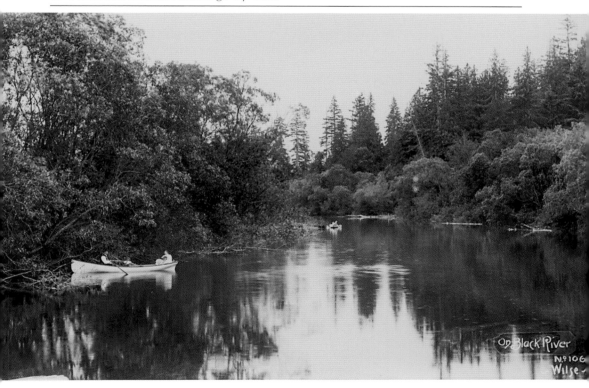

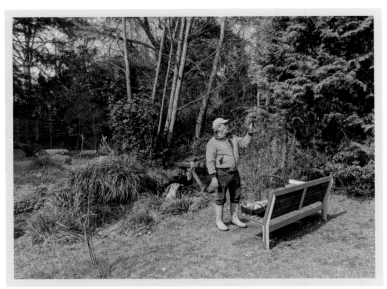

Lyon Creek, in Lake Forest Park, is one of several streams that feed Lake Washington. In this 1910 Asahel Curtis photograph, Ole Hanson, real estate developer and later mayor of Seattle, demonstrates the purity of the water. Decades of urban development and industry took a toll on the health of these creeks and their wildlife. In recent years, environmental groups have taken steps to restore stream health. Here, Mark Phillips of Lake Forest Park Streamkeepers makes his own tests of water quality in Lyon Creek. (Courtesy SHM.)

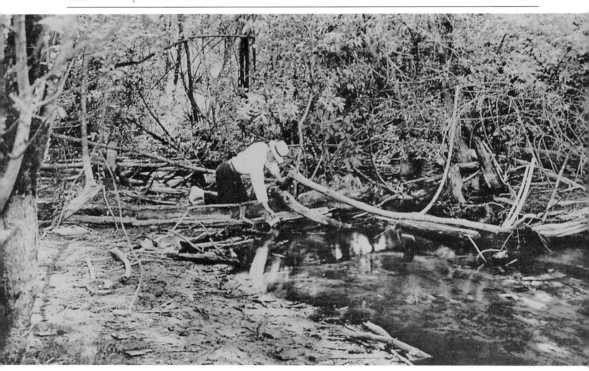

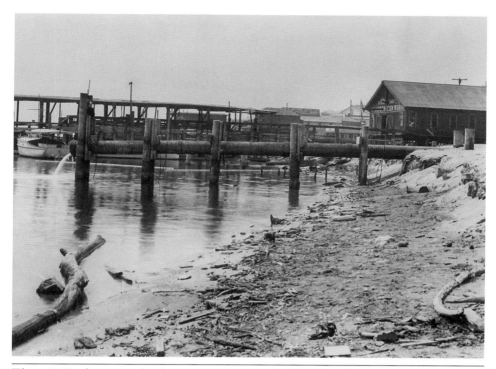

The 1917 photograph shows one of several sewer outfalls draining into Lake Washington shortly after the lowering of the lake. For decades, sewage and toxins poured into the lake, choking it with algae and making it dangerous for both swimmers and wildlife. In the 1960s, a major cleanup effort improved the situation, and today, domestic wastewater is directed away from the lake and treated. The outfalls remain in place to handle emergency stormwater runoff. (Courtesy MOHAI.)

With the lake lowering in 1916, a wide swath of Union Bay drained away and became wetlands. In 1926, the area became a city landfill called the Montlake Dump, seen here in 1954. Forty years later, environmentalists put an end to the degradation of the area, and restoration efforts began under the auspices of the University of Washington. It is now a protected preserve called the Union Bay Natural Area, although birders still refer to it as "the fill." (Courtesy SMA.)

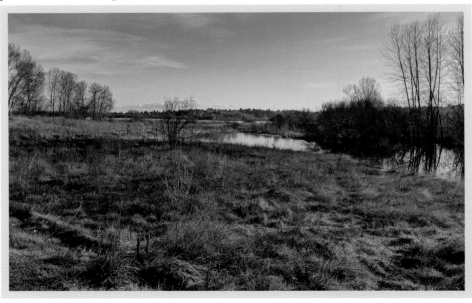

ECOLOGY OF THE LAKE

Like Union Bay, Wetmore Slough, on the lake's southwest shore, was used as a dump after the lake waters receded. John Parker recalled the early days: "It was full of big water willows and it always had water in there. Everybody had outdoor toilets, but later on, as the population grew, the crick became an open sewer and it dumped right in to where the Stan Sayres pits are [now]." In the late 1960s, with Forward Thrust bonds, the extensive landfill was capped and turned into Genesee Park. (Courtesy SMA.)

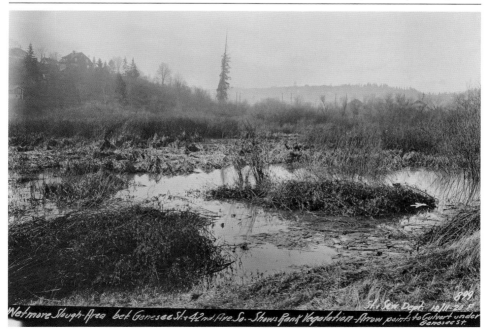

Lake cleanup is not a done deal. A section of lakefront in the Kennydale area contains a Superfund site. Once called Port Quendall, it was home to the Barbee sawmill and other businesses that soaked the ground and groundwater with oil, tar, and creosote. Although the structures were demolished by 2006, much of the pollutants remained. The northern portion of Port Quendall, cleaned up, is now the Virginia Mason Athletic Center (VMAC), home to the Seattle Seahawks. Today's photograph echoes the 1985 shot of the mill grounds. (Courtesy RHM.)

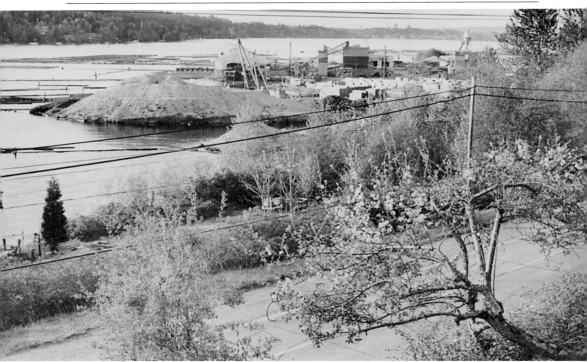

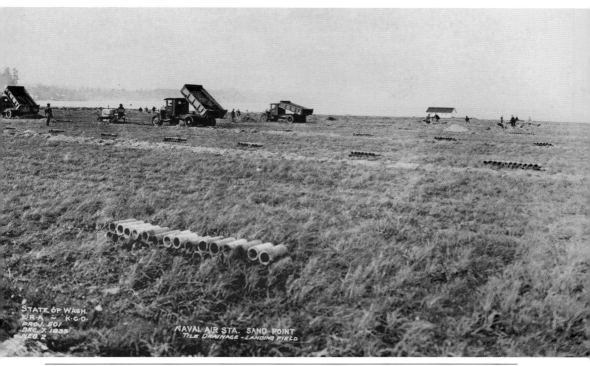

During the 1930s, the Navy converted Sand Point peninsula into an airfield, grading, installing drainage, filling a small lake, and paving airstrips. In 1977, following deactivation of the naval base, the City of Seattle designated the area Warren G. Magnuson Park and began converting it to recreational purposes. The shoreline consists of walkways and a few remaining military outbuildings and bunkers. The present photograph was taken from the side of Kite Hill, a prominence created from the rubble of old airstrips. An art installation of submarine fins takes center stage. (Courtesy SMA.)

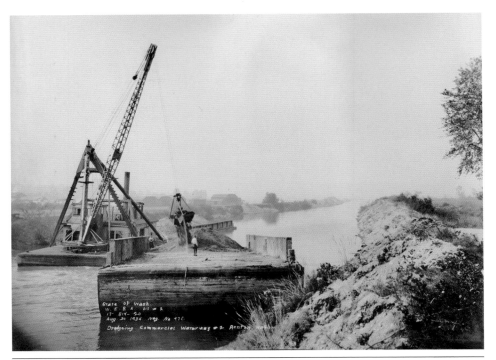

The last stretch of the Cedar River, already rerouted into Lake Washington in 1912 to control flooding, was dredged out to improve navigation in 1934. Commercial Waterway District No. 2, created to maintain the channel, operated until 1957. Gwen Kinne recalled the danger to Renton: "I particularly remember one time [in 1911] when it was feared that the dam on the river would break. The whistle blew many times and sent us scurrying to the hill above Kennydale." (Courtesy WSHS.)

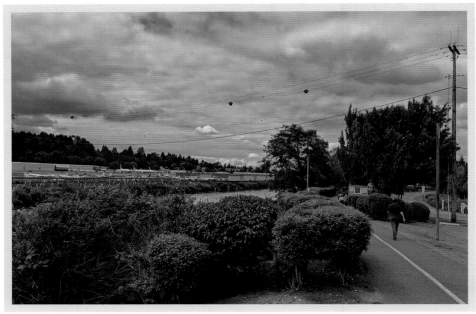

ECOLOGY OF THE LAKE

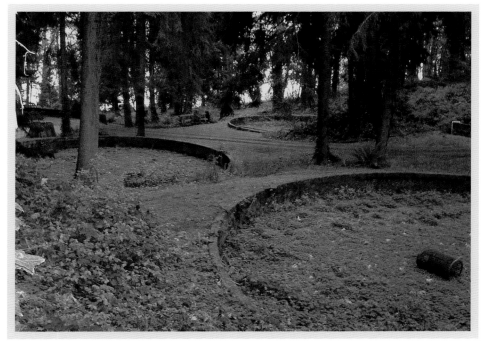

Fish ponds are shown being built at Seward Park in 1935. Salmon and rainbow trout were reared in 20 ponds in an effort to keep the lake and its rivers stocked for fishermen. The hatchery ceased operation in 1992, but remnants of the ponds still exist behind chain link. (Past image courtesy MOHAI; present image courtesy Mikala Woodward and RVHS.)

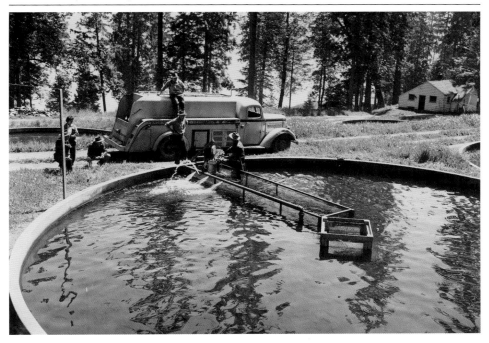

Discover Thousands of Local History Books
Featuring Millions of Vintage Images

Arcadia Publishing, the leading local history publisher in the United States, is committed to making history accessible and meaningful through publishing books that celebrate and preserve the heritage of America's people and places.

Find more books like this at
www.arcadiapublishing.com

Search for your hometown history, your old stomping grounds, and even your favorite sports team.

Consistent with our mission to preserve history on a local level, this book was printed in South Carolina on American-made paper and manufactured entirely in the United States. Products carrying the accredited Forest Stewardship Council (FSC) label are printed on 100 percent FSC-certified paper.

MADE IN THE USA